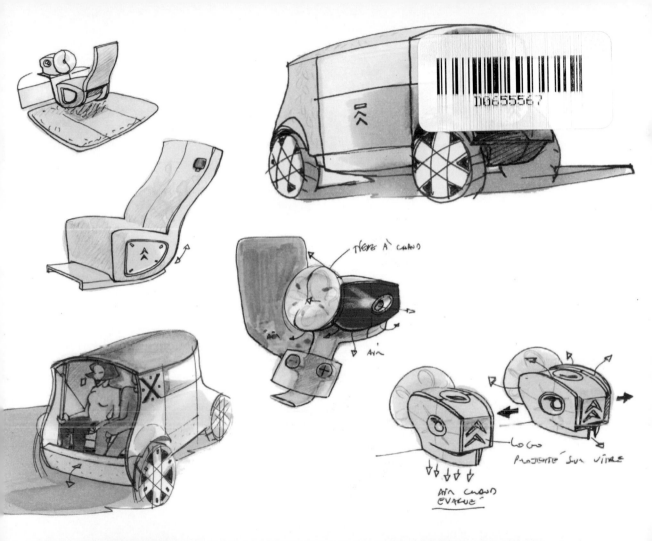

tiède à chaud

air

air

logo
projeté sur vitre

air chaud
évacué

DAFT CARS

MATT MASTER

BBC
BOOKS

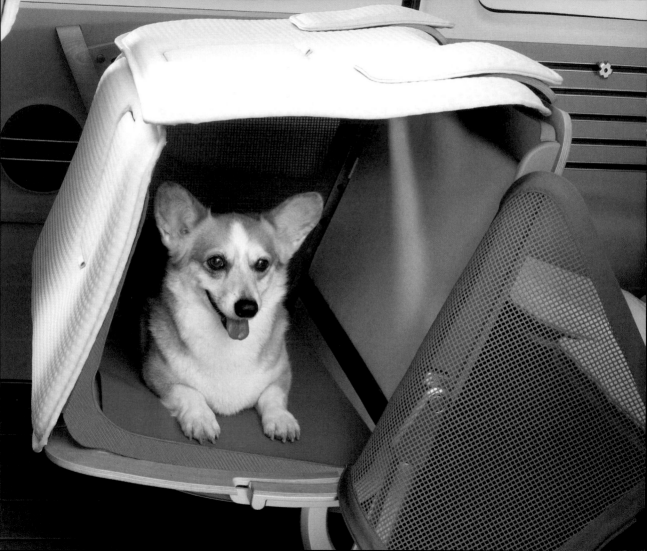

CONTENTS

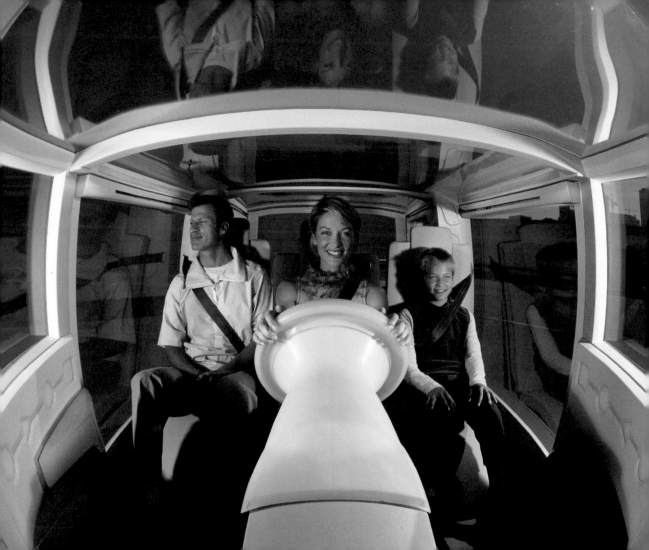

INTRODUCTION

Man has been making cars for well over a century, and he's got pretty good at it. Wheels, engines, seats, windows, bits of chrome and bits of leather; it's a foolproof formula. Or so we thought…

In a bid to save themselves from extinction, car designers have been reinventing the concept on a daily basis. How about something amphibious? Aeronautical? No? Well have you considered the performance benefits of going nuclear?

All too often, when that bright spark in the boardroom should've been given a polite smile and a firm shove through the door marked 'Dole Office', he gets a pat on the back and a blank cheque. And a few weeks later, out pops a shiny scale model, say, or a concept for a motor show, or, in the worst nightmares of cash-strapped CEOs, a fully-fledged production vehicle.

This is *Top Gear*'s rundown of the most laughable collisions of the brilliant and the bonkers, when ambitious seeds grew into virulent weeds, when the best intentions became the worst inventions. We've got cars that look after your mood and cars with moods of their own. There are mobile kennels, fish-shaped hatchbacks, cars that are boats and cars that are boozers.

It's not all bad, though. Some of it gets full marks for effort. Some of it isn't actually that wide of the mark, either. And there's even the odd one you just can't help but admire. From a safe distance, mind you.

1 COMPANY CREDIT CARD

With open access to the company's coffers and the boss letting go of the reins, it's nothing short of terrifying what some people come up with in the name of business.

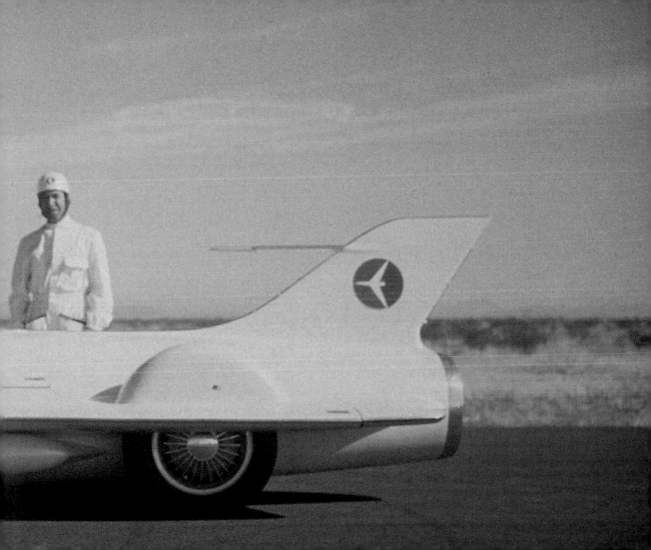

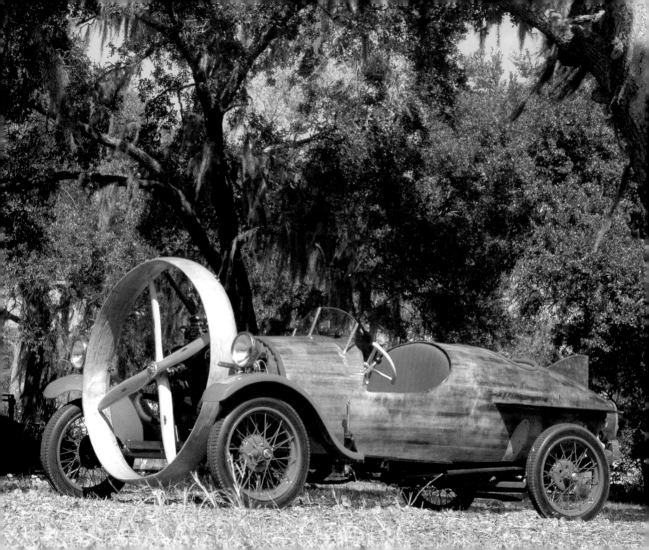

Year: 1932
Well someone had a go, didn't they? And then hid it in a shed.

HELICRON NO. 1

The First World War created a booming trade in aircraft that the French, playing host to proceedings, didn't fail to notice. Or cash in on. But with the war over, boom became bust, and various plucky French entrepreneurs began insisting that propeller power was the answer to everything else. Oddly, they were proved wrong, denying the rest of the world the spectacle of twin-prop cheese-makers and wine barrels with tailfins, but not before we got the Helicron No. 1.

After languishing in a barn in rural France for over sixty years, the Helicron was finally rediscovered in 2000 and lovingly rebuilt. It has to steer via its rear wheels due to an unforeseeable obstruction at the front and, despite that, is thought to have achieved speeds of around 75mph. It's called the No. 1 for the simple reason that only one was ever made, presumably before the designer was sectioned or shot.

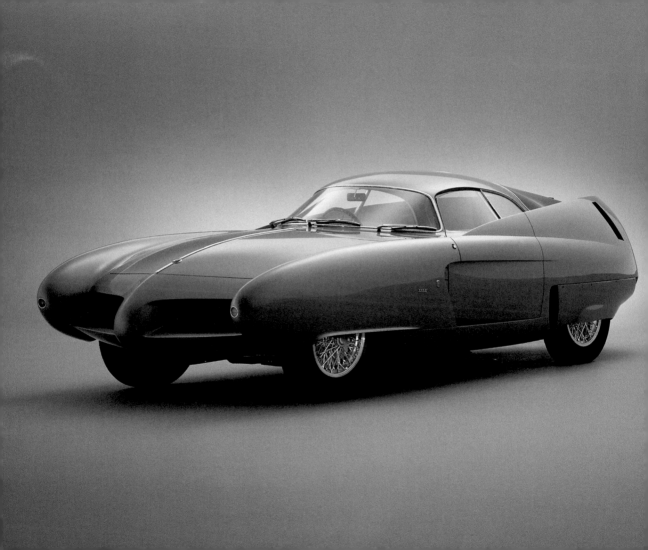

Year: 1954
It's an Alfa Romeo. We're just happy when one starts.

ALFA ROMEO BAT 7

Normally, it's all Alfa Romeo can do to get its cars to start, so back in the '50s it must've seemed like the height of optimism when design house Bertone decided to spend a king's ransom exploring the virtues of aerodynamics. But Italian car builders are nothing if not ambitious, so, with Alfa Romeo's blessing, Bertone came up with a series of cars called the BAT. Stupid, on reflection, to name your car after a blind, winged rodent, but it stood for Berlinetta Aerodinamica Tecnica, which no one had the time or energy to write.

The BAT cars were actually quite clever in a scientific sort of a way, with long rear ends, fared-in wheels and weird swirling fins that achieved something called a drag coefficient of 0.19. That's pretty much as meaningless to most of us now as it was then, and all the more so if you are going to spend the next fifty years encouraging your cars to rust faster than they can accelerate.

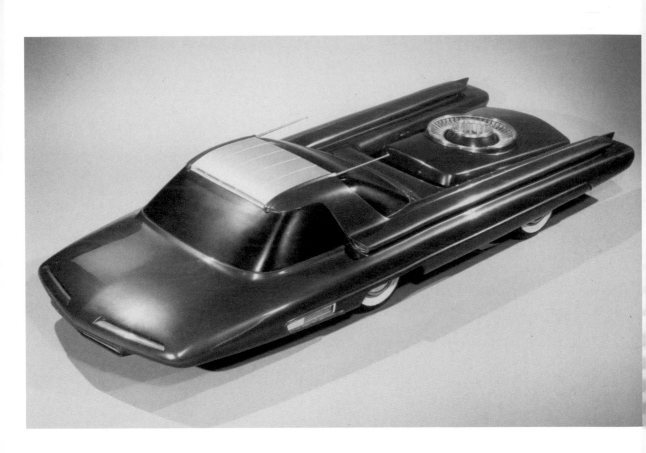

Year: 1958
It'd be safer to run a car on the Ebola virus.

FORD NUCLEON

The frontier of science in the 1950s was all atomic. Under the (mushroom) cloud of mutually assured destruction, minds ran riot. Almost every comic-book character you cared to mention was the atomically charged by-product of a nuclear mishap, and the bog standard vision of the future was one of limitless energy, doors that went whoosh and his-and-hers matching silver jumpsuits. Into this daydream, somewhat inevitably you might say, the Ford Nucleon silently glided.

The idea of a car with a radioactive core suspended over its rear axle might set alarm bells ringing today, but in the halcyon pre-Chernobyl era, when you only had to hide under a mattress for a couple of weeks to sidestep a nuclear fallout, this was the business. The Nucleon was only ever a model, thank God, but in theory would have been capable of 5000 miles between fill-ups, with interchangeable reactors, depending upon your performance needs.

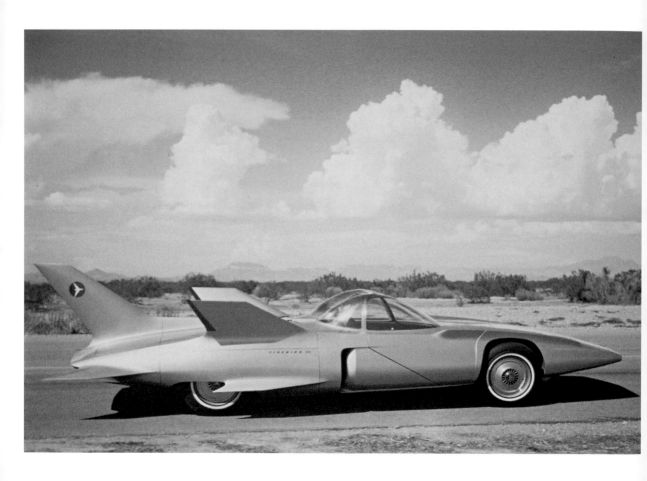

Year: 1958
Yes, they've made these before. They're called planes.

GM FIREBIRD III

While Ford was mucking about splitting the atom, the boys at General Motors were doing something a little less scientific. Although no less certifiable. The Firebird project was an attempt to fit gas-turbine engines into road cars. What it amounted to was jet planes without wings. The first effort is said to have hit 100mph in first gear, but not been able to maintain any grip whatsoever in second. The next evolution endeavoured to be a tad more user friendly, in that it had four seats, instead of just the one, and some headlights. But that was it.

By the time Firebird III appeared, any attempt to deny its aviation origins had been abandoned, and the car had a double-bubble canopy, a joystick for steering and no less than seven mini wings and tailfins. On a more practical note, it did have air conditioning and cruise control, which is quite impressive for 1958, but they had to fit a petrol engine to get any of it to work as the jet engine was too busy overheating.

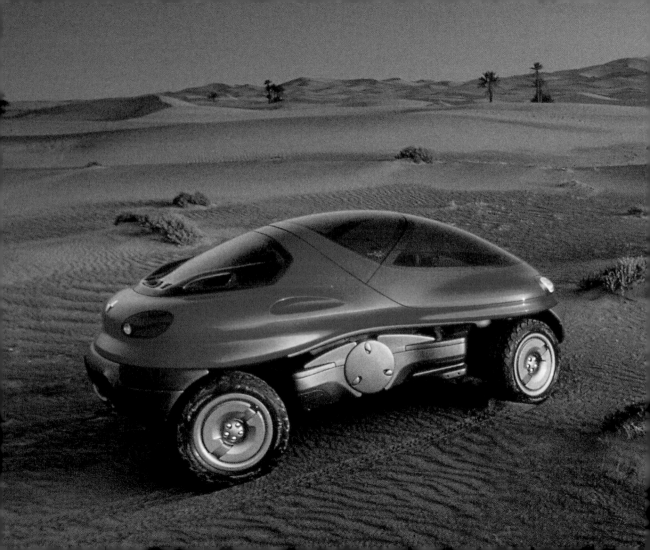

Year: 1993
The answer, if not the antidote, to global warming. It's a sure thing.

RENAULT RACOON

As this book will testify, France has been responsible for a disproportionately high number of the more severe acts of recent automotive lunacy to disgrace the halls of motor shows and design studios. Seemingly a knee-jerk response to the world's assumption that all Renault was good for was cheap, straw-filled hatchbacks in which its daughters could pass their tests, it came up with the Racoon.

Here was a car designed to do everything. It's an off-roader for starters, with four wheel drive, those massive tyres and adjustable ride height. But it's also a performance car, with a twin-turbocharged V6 and manual gearbox. Not satisfied with this already ambitious level of cross-pollination, Renault then decided to make it amphibious, with two water jets powered by the engine to take the Racoon up to 5 knots in water. Then, just to make their intentions entirely clear, they named it after an outsized, tree-dwelling North American rat that usually has rabies.

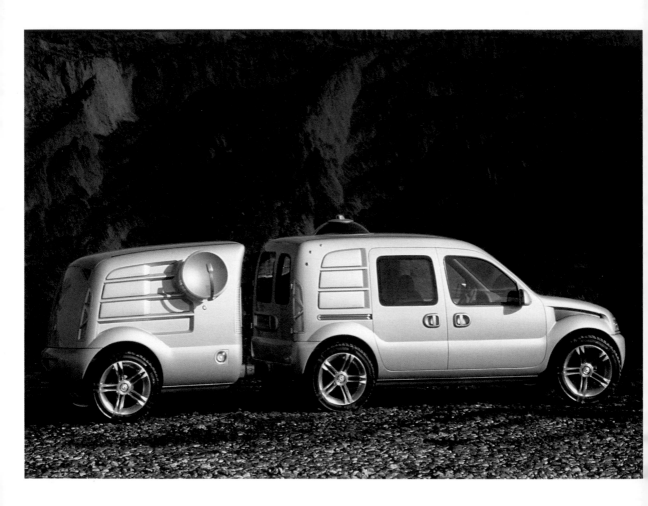

Year: 1997
A van with a laptop in the boot? Let's keep our feet on the ground.

RENAULT PANGEA

With the August bank holiday an eternity away and the office air con on the blink, in between swatting flies and knotting their ties into a massive hangman's noose Renault's designers come up with things like this.

The Pangea is a purpose-built scientific and environmental exploration vehicle – or a thinly veiled attempt to sex up the then imminent van-based Kangoo MPV, on which it is based. Equipped with an electric–LPG hybrid drivetrain, it tows that massive trailer around in order to be able to refuel itself and, in the process, presumably halve the available mpg it had in the first place. On board, Renault's restless desk jockeys assure us, is an analysis laboratory and communications centre – that's a laptop and a mobile phone to you and me – and that lump on the roof is a 360-degree panoramic camera, so you don't have to use anything as antiquated as your mirrors.

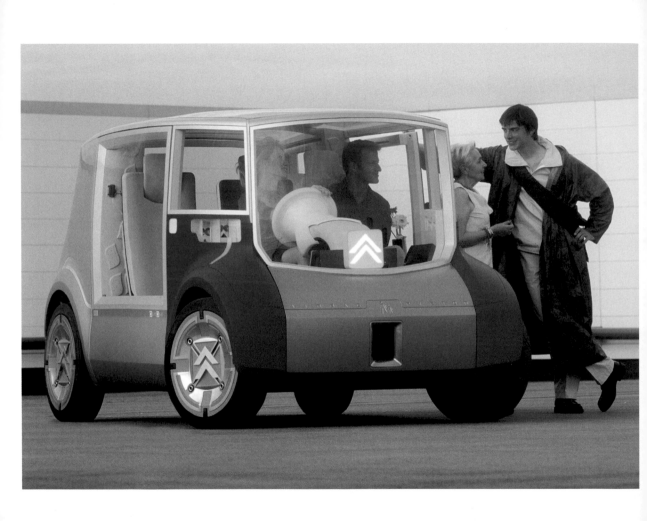

Year: 2001
Not unless you want to wake up naked in a lay-by, minus a kidney.

CITROËN OSMOSE

A scary, left-wing vision of motoring Utopia, the Osmose promised, in Citroën's own words, 'a new form of relationship between pedestrians and motorists'. Considering the traditional relationship usually involves an abrupt and untimely death, this can only be a good thing – but just how radical was Citroën really being?

Not very, as it happens, because the Osmose is essentially a cross between a Routemaster bus and a minicab. But one you actually have to buy yourself, before giving lifts to everyone else. So it's already not what you'd call a great business model. The gimmick with the Osmose is that you can advertise your destination on the front so that random passers-by not only know where you're going but can also tag along, if they want. Not ideal if you're having an affair or fleeing the scene of a crime. Although Citroën deserves a biscuit for high-minded, *Guardian*-reading eco-ness, essentially the Osmose is an expensive solution for those cardboard signs wielded by weirdos at roundabouts, that have 'Blackpool' or some such written on them in crayon.

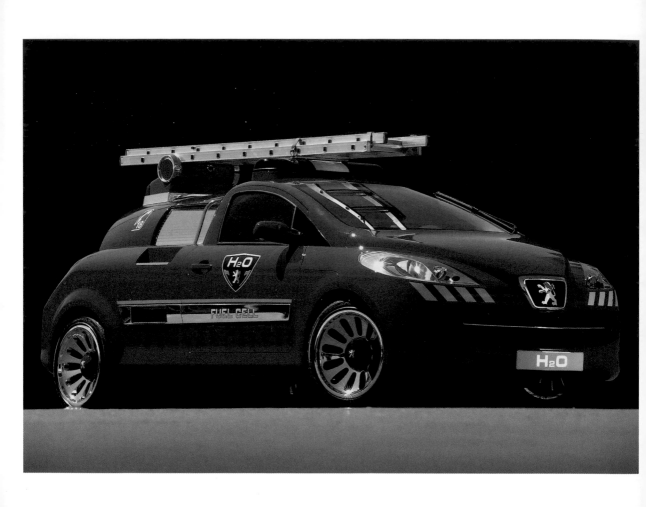

Year: 2002
You'd have to make one to put out the other. Could get tedious.

PEUGEOT H2O

One of the inherent difficulties with car ownership in France is the strong likelihood that, on several occasions, you will have your pride and joy set on fire by disaffected youth. Rioting is in the Gallic blood in equal quantities to garlic and red wine. It's the very raison d'être of every hard-working Frenchman, and a day without torching a couple of cars in the name of something vaguely socialist is a day wasted.

Then there's the issue of France's streets. Britain doesn't have much to shout about on this score either, but trying to drive a fire engine through Paris in time to douse a spot of spontaneous arson is much like trying to give birth. Probably, anyway. You need lots of professionals on hand and an epidural at the very least. So Peugeot devised the H2O, or, rather, it took the 206, which by this stage was getting pretty long in the tooth, and turned it into a fire engine. The H2O is powered by a fuel cell, so there's an environmental upside to suppressing the nation's inbuilt anarchy; what with it only emitting water vapour, you'll extinguish burning cars just by driving past them.

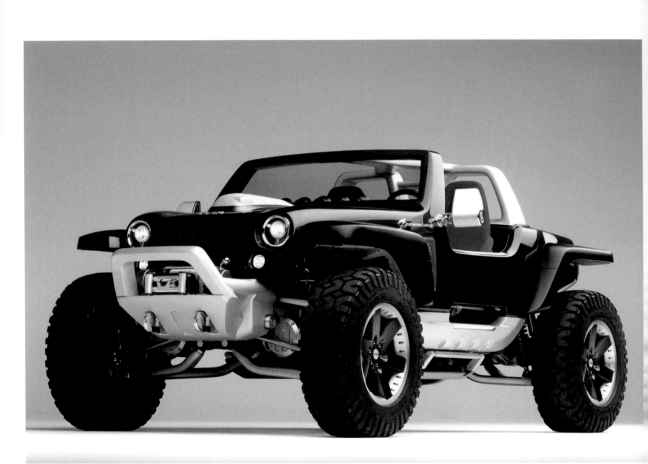

Year: 2005
The only thing going sideways in America right now is the economy.

JEEP HURRICANE

It's a fact widely acknowledged about American cars that, almost without exception, they are astonishingly bad. Crisp-packet plastics and dodgy wood veneers, rubbish handling and terrible economy. But one of the few diamonds in the rough, although a pretty shoddy diamond it remains, is the Jeep, and only then because it's genuinely impressive off road.

Someone in a suit at Jeep must have realised this and ordered someone with a sketch pad to order someone with a spanner to distil the very essence of Jeep. In a moment of inspired insanity, they dispensed with everything that was rubbish about their cars, like doors, windows, interiors, styling, and concentrated on the only thing they could do properly. The upshot was the Hurricane, a four-wheel drive system with a couple of seats bolted on top. And a pointless trick up its sleeve …

Since not doing very much of note had created an awful lot of free time at Jeep HQ, they decided to lark about with the steering, and when the Hurricane appeared it had the singularly useless facility of being able to drive sideways. No one knows what for. The man with the spanner probably got fired.

Year: 2008
Um, it's a wet weather wheelchair. Isn't this cheating?

SUZUKI PIXY

What with the certainty that the next generation is going to be morbidly obese – those, that is, who survive the bird-flu pandemic – surely there couldn't be a more suitable car for tomorrow than the Suzuki Pixy. This is one of those 'personal mobility units', essentially an airtight wheelchair that fits neatly into Japan's dystopian vision of the future, where no one walks anywhere or talks to one another in case they catch something.

The Pixy is meant for pavements and, believe it or not, indoor use, because, Christ, you wouldn't want to have to walk to the elevator now, would you? Should you have to go any serious distance, like to the end of the street or something, there's the SSC to come and pick you up too. That stands for Suzuki Sharing Coach, quite seriously, and the SSC is essentially just a posh box on wheels into which you can drive a couple of Pixies before heading off into the great unknown. Or to the postbox.

2 AGE OF UNREASON

Progress takes many forms, reflecting the social, cultural and scientific shifts that have shaped modern man. But sometimes man is clearly just bored out of his mind.

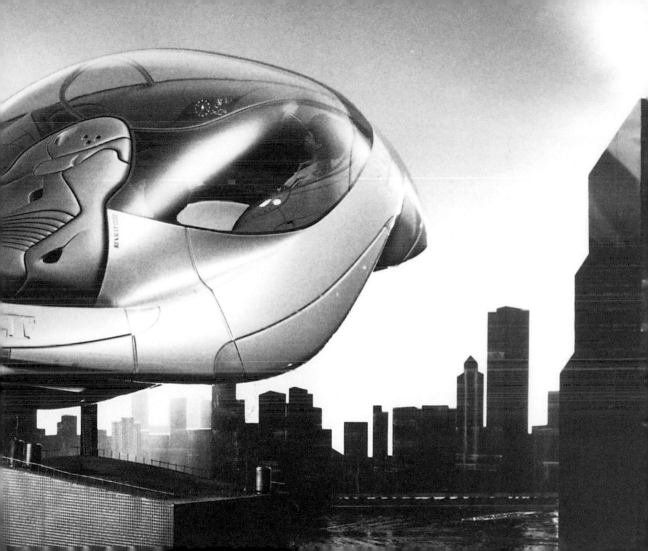

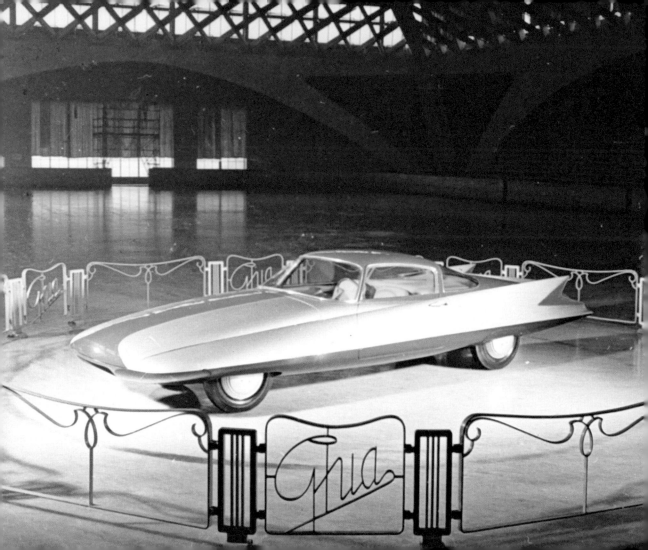

Year: 1955
It didn't work fifty years ago. We don't fancy its chances.

GHIA GILDA

Progress has its collateral damage, and the car industry seems to get hit harder than most. For every half-formed idea for a new vehicle, there's bound to be a bit of unimaginable tosh that couldn't withstand cross-examination from a toddler. The Ghia Gilda is just such a piece of pseudo-scientific fluff. Back in the '50s, a lot of clever people were finally getting down to brass tacks with aerodynamic efficiency, perfect handling balance and unprecedented levels of performance in their cars. And some were just making things that looked dead fast and swoopy.

Ghia was, and just about remains, a respected styling house, but the Gilda, the disastrous love child of a hurried Italian–American design liaison, isn't its finest hour. The suggestion was that the Gilda had been carefully designed in a wind tunnel and intended to have a gas-turbine engine that would rocket it to over 140mph. The reality was that no one had the slightest idea what effect a breath of wind would have on the car's unlikely form, and that even 40mph was probably an utter pipe dream with a wheezy little four-pot petrol engine stashed away beneath its vast bonnet. Cracking paint job, though.

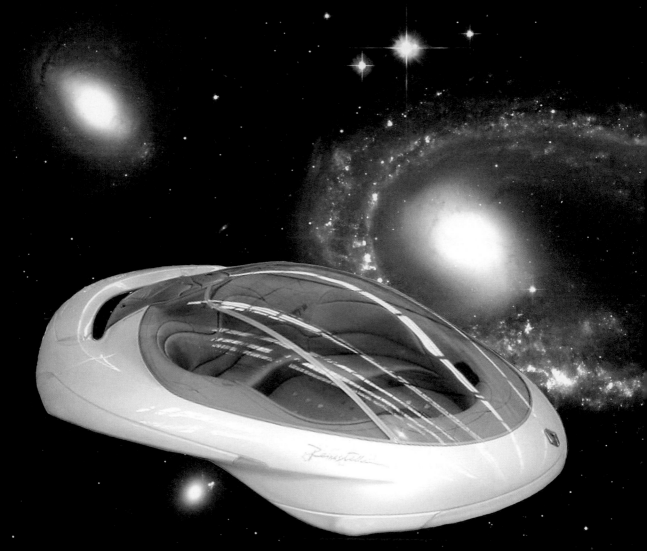

Year: 1992
It looked out of place at EuroDisney. Not a good sign.

RENAULT REINASTELLA

There is a legend put about by Renault that the launch of the Reinastella concept car was put back by a day, to 2 April, so no one thought it was an April Fool's joke. However, this overlooks the fact that whichever day you choose to look at it, Renault was still clearly taking the piss.

Conceived as a vision of personal transport in the year 2038 – which back in 1992 might have seemed a little bit more radical – however you try to dress it up, the Reinastella is really just a French flying saucer. As if secretly admitting defeat, Renault ended up exhibiting it at the then recently opened Euro-Disney resort outside Paris, where, instead of being dismissed out of hand by sceptical adults, it could be dismissed out of hand by hordes of kids instead.

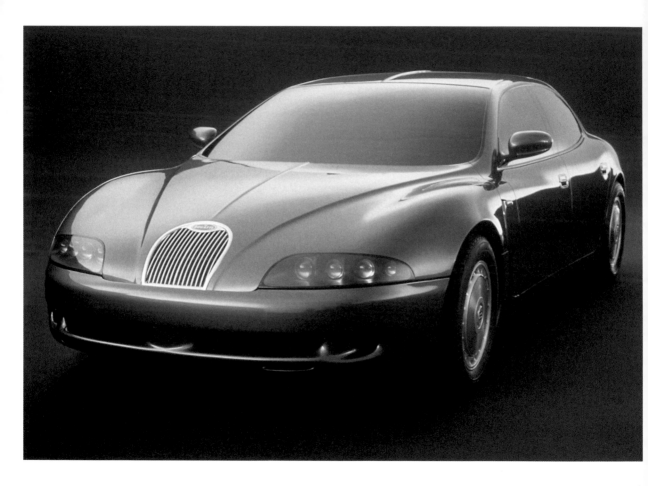

Year: 1993
A ray of sunshine for every fertile oil sheik. Watch this space.

BUGATTI EB112

It took Bugatti, or Volkswagen to be more exact, the best part of a decade to deliver on the Veyron, the world's fastest, most expensive and utterly unnecessary production road car. And that's understandable. Beyond the challenge of keeping around 1000bhp in contact with the road, there was also the very real anxiety that no one would actually want to spend nigh on a million on a strange-looking VW that might accidentally enter Earth's orbit.

In order to maximise the number of potential punters therefore, Bugatti initially went to work on the EB112. Still clearly a sports car — what with a 455bhp 6.0-litre V12 under the hood and a 190mph top speed – it was also a saloon car to appeal to executive business types, who could sit in the back and do grown-up stuff on their mobiles, and a sort of hatchback-cum-estate to appeal to their wives and girlfriends, who would doubtless need to hit the shops. So, that way, everyone's happy and, hopefully, happy to chip in too.

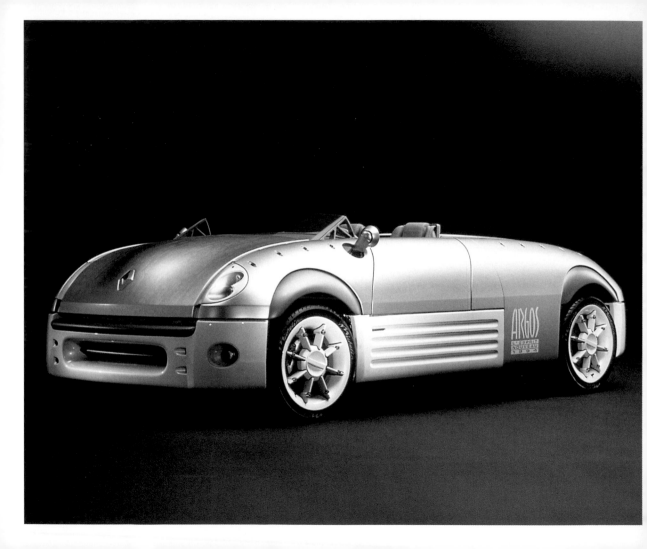

Year: 1994
Taking all the individuality and colour out of cars? That's Vauxhall's job.

RENAULT ARGOS

Naming a car after a chain of slightly crappy shops where everything's kept in the cellar might seem foolish, but there is good reason. The Argos was a styling exercise in utilitarian simplicity or, put another way, a shocking rush job. Renault's designers evidently had a pressing appointment with the local knocking shop because they couldn't have put less effort into the Argos if they'd drawn it in their sleep. No doors, windscreen, roof or windows, and a front end that looks exactly like the back end, or vice versa. This absence of superstructure is meant to improve the sense of symmetry and not interrupt the minimalist equilibrium. Which is the design equivalent of telling Sir that the dog ate your homework. And to make matters worse it's really just a first-generation Twingo underneath.

Choosing a complementary colour is also a vital aspect of car design, and here the Argos really shines. Or rather it comprehensively fails to, by being a uniform matt grey absolutely everywhere.

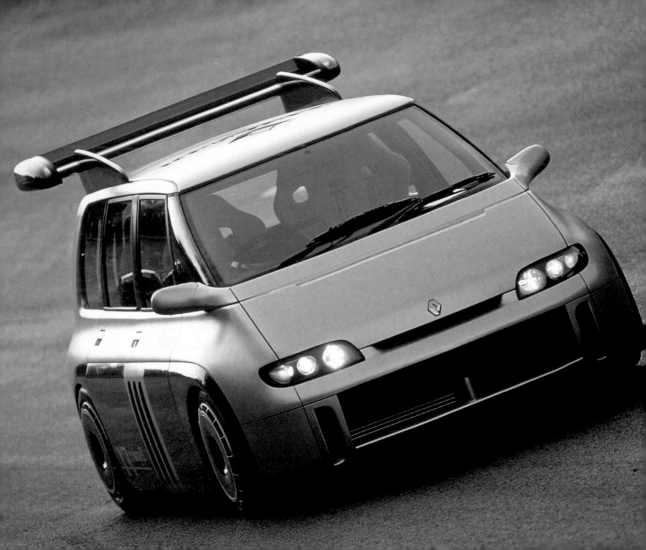

Year: 1994
So long as there's a pit crew in the Tesco car park.

RENAULT ESPACE F1

There are moments of motoring madness that, for all the fear they engender in us innocent bystanders, do muster a whiff of admiration at the same time. If your bosses are spending the GDP of a small European country competing in Formula 1, what better way to promote your glamorous excess than by shoe-horning a real, live F1 engine into a common-or-garden road car?

It doesn't take an expert in human behaviour to work out that whoever came up with the Espace F1 was very clearly taking the piss. Actually based on a proper Williams F1 car chassis, but with a bespoke Espace body formed out of lightweight carbon fibre and Renault's F1 engine slap-bang in the middle, the Espace F1 wasn't exactly school-run material; nor was it going to be winning any races. But as an act of absurdist indulgence, there are few things finer than an MPV with a roof spoiler that'll hit 60mph in under three seconds and top out at a whisker under 200mph.

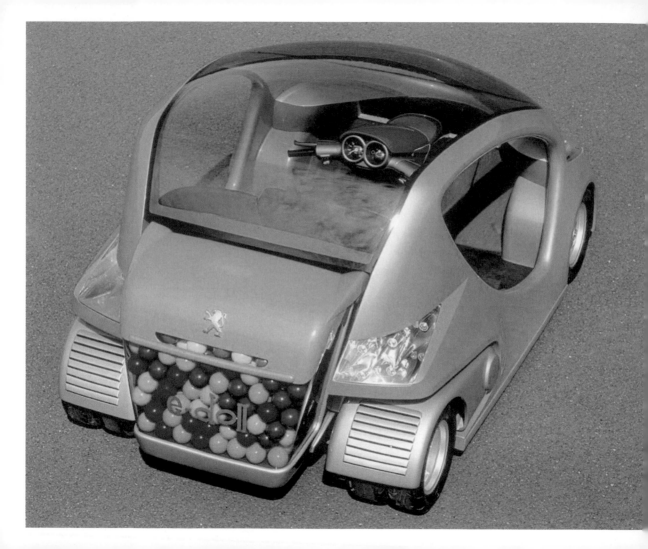

Year: 2001
If car design is left up to pre-schoolers with ADD, then absolutely.

PEUGEOT E-DOLL

In a desperate bid to put a positive spin on inner-city motoring in the new millennium, Peugeot created a series of cars in 2001 called 'City Toyz'. Naturally, the needless use of the letter 'z' set alarm bells ringing everywhere, but not in time to save us from the 'e-doll'.

Comfortably the most dreadful of all the Toyz, the e-doll is meant to be some sort of electric mobility scooter-cum-shopping trolley. It seats three side by side under a one-piece carbon-fibre canopy that also houses the batteries for a couple of electric scooter engines. At the back is a detachable, transparent shopping cart, like one of those tartan jobs old ladies drag around the supermarket, but Peugeot has filled it with brightly coloured plastic balls to remind us all how fun life is and how young and happy we all are. Not just a posh, orange version of those things old people trundle into the bingo then? No, definitely not. It's got brightly coloured plastic balls in it, after all.

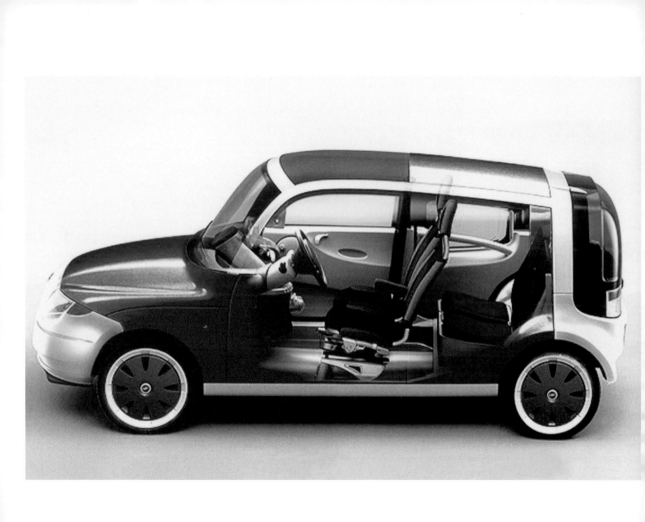

Year: 2004
Noddy goes vegan. It's horribly plausible these days. Which is upsetting.

FIAT ECOBASIC

The one thing no one wants to imagine Fiat doing is spending even less money on producing cars. Already the whipping boy of the European car industry for its endless succession of substandard hatchbacks that most people only encounter while trying to avoid hiring them at Italian airports, it hardly seems possible that Fiat could cut any more corners. But then the Ecobasic appears.

This is a car specifically designed to be cheap to make. That there may be a knock-on reduction in price to the consumer is by the by when you consider the maxim that you get what you pay for. In this case what you pay for is a giant piece of pre-dyed red plastic, to which all you can do is take more things away – fewer seats, fewer doors, that sort of thing. It has a 1.2-litre engine that is sealed up and completely inaccessible to the owner on the grounds that it will always be reliable enough not to need any attention. Cue the canned laughter.

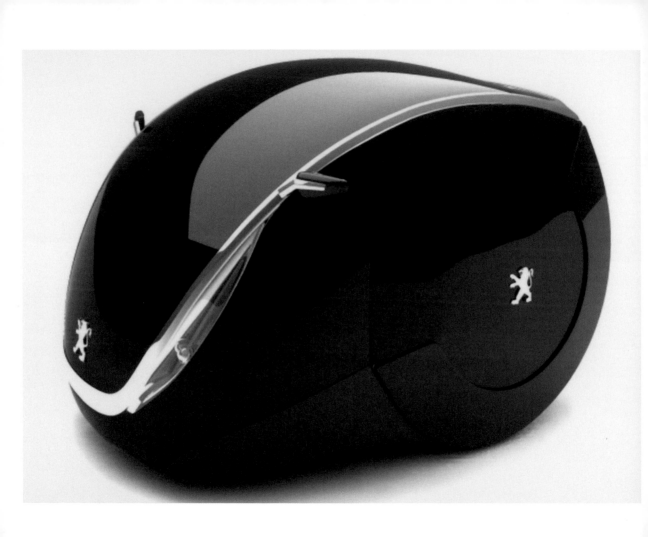

Year: 2005
If it's just hamsters that survive the apocalypse, this is a shoo-in.

PEUGEOT MOOVIE

Letting Joe Public design cars is an exceptionally bad idea. It's the automotive equivalent of a late-night radio phone-in – everyone's got something to say, but everyone's also drunk, suicidal or clinically insane. The pinnacle of Peugeot's rash act of democracy came in 2005, when the winner of its third annual design competition came up with this, the Moovie. And that's not a typo. It's impossible to imagine anyone even saying Moovie without promptly being slapped, and that's before you've actually laid eyes on the car.

Enormous circular doors conceal similarly vast wheels behind them. Meanwhile, inside, there's absolutely sod all except a steering wheel and a couple of rather uncomfortable-looking plastic chairs. The not-altogether-hopeless theory is that the big wheels have to turn less, thereby using less energy, although the Moovie's clearest green credential surely lies in the universally felt disincentive to be seen driving a geometric goldfish bowl.

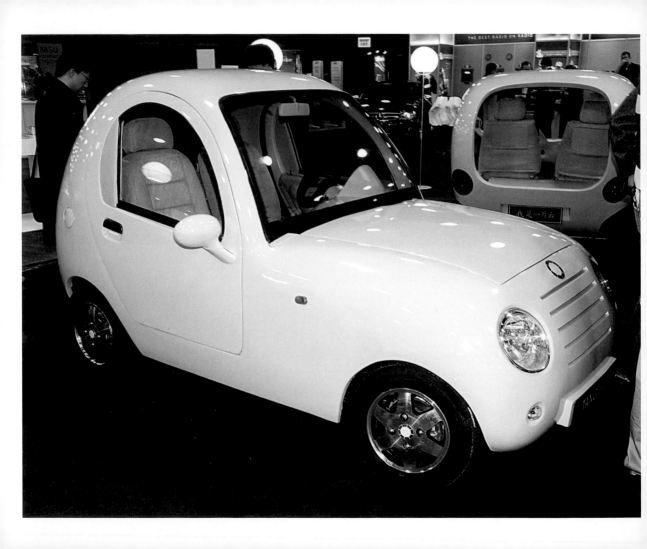

Year: 2008
A more disturbing Chinese export than Sars, but less likely to be catching on.

TANG HUA BOOK OF SONGS

There is almost nothing about Tang Hua's compact city car that doesn't render the casual observer speechless. Firstly, there's the name, and it's worth mentioning that the Book of Songs was unveiled to a gawping public alongside the Tang Hua Piece of Cloud and the Tang Hua Detroit Fish. No rhyme or reason, so best you just don't ask.

Then there's the styling, which is, um, unconventional. On even the most cursory inspection, a strong suspicion arises that Chinese designer Li Cuangming is, at the outside, aged five. He has been quoted as saying that all three of his bright yellow electric cars, which looked somewhat out of place in the heart of Motor City at the 2008 Detroit Motor Show, 'have the Chinese spirit in their design'. That, you can be fairly certain, is the Chinese spirit also known as vodka.

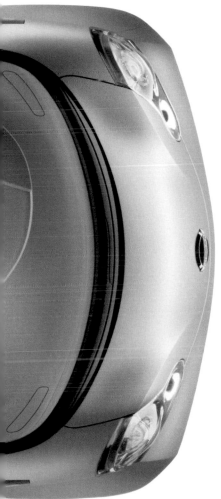

3 METHOD IN THEIR MADNESS

Very occasionally on Planet Car, all is not what it seems. Look hard enough and you might just see a glimmer of logic beneath that ludicrous exterior. On the other hand ...

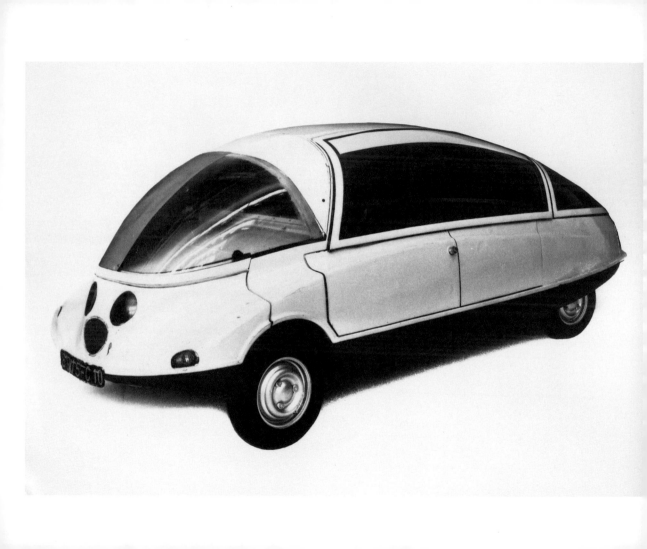

Year: 1953
It's happening right now. Sadly for Citroën it's called the Toyota iQ.

CITROËN C10 COCCINELLE

There's something quite impressive about the sort of foresight that encouraged Citroën to build a tiny sperm-shaped bubble car way back in 1953. The roads were empty, petrol was practically free, and America was setting the cultural standard with proper, penis-shaped cars the size of aircraft carriers, bulging with V8 engines and chrome-covered tailfins.

But the Coccinelle was the real deal. A bona-fide four-seater that weighed just 382kg, thanks to its narrow-gauge aluminium construction; it was also streamlined in a for-science-not-sex fashion and used the same engine as the original 2CV to get it up to almost 70mph. The thorn in Citroën's side on this one was that half the car's potential market was instantly scrubbed out. *Coccinelle* is the French for 'ladybird'.

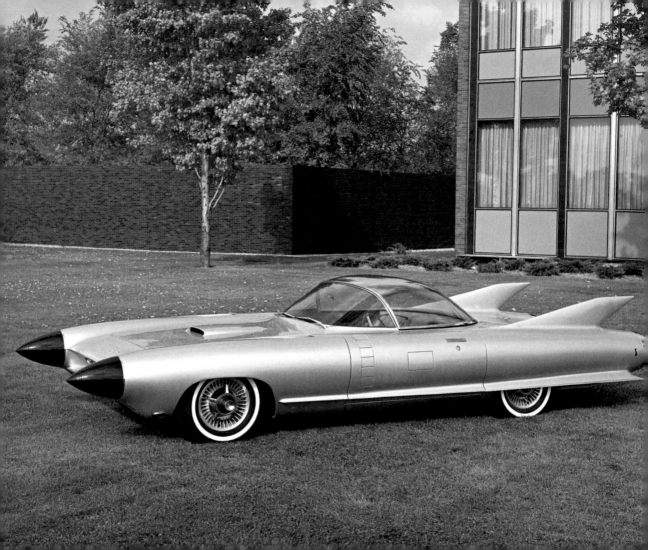

Year: 1959
The idea is on the market, although regrettably minus the styling.

CADILLAC CYCLONE

Following the mandatory '50s design motif of fighter-jet-cum-spaceship, the Cadillac Cyclone is blessed with endless dippy shite, like a bubble canopy, mock afterburners and a front end that looks like a pair of intercontinental ballistic missiles. But underneath all this pointless gubbins was something that would take a further half-century to be properly realised on a production car.

Hidden behind those unlikely black nosecones, the Cyclone carried two radar systems that were intended for crash avoidance. They could scan the road ahead, sense if an object were in the car's path then warn the driver with a light on the dashboard and an audible signal. Mercedes-Benz has only just started rolling out this technology, albeit along with automatic braking, as a pricey option in their poshest cars. The rear-hinged bubble canopy was also meant to sense rain and open without any human input, creating, at a guess, a lethal airbrake that the driver could do nothing about. Still, one out of two.

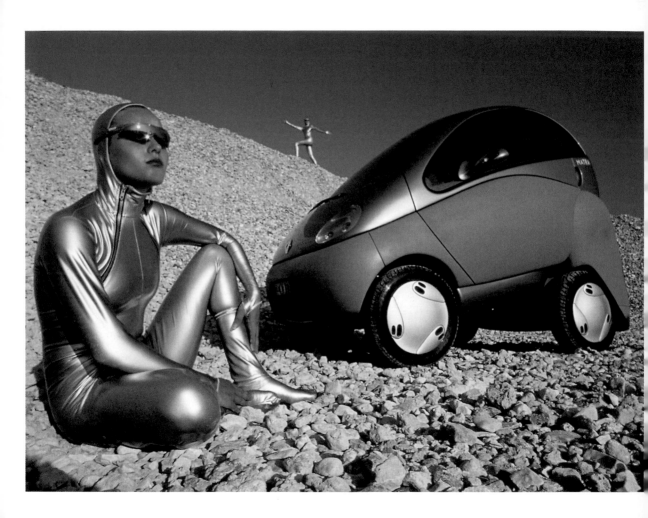

Year: 1992
Ingenious, and essentially a giant nutcracker. There will be lawsuits.

RENAULT ZOOM

Thus far your suspicions will be rife when it comes to Renault, the company with perhaps more dirty design secrets in its closet than any other. But, occasionally, albeit with the regularity of a virgin birth, they do pull something out of the bag. The Zoom appeared in the early '90s when, let's face it, no one really gave a damn about the environment, and big, in cars as in all things, was still essentially beautiful.

The Zoom, however, was tiny and all-electric, with a 25kw motor that aimed to be 90 per cent recyclable, and that's something manufacturers still haven't got their heads around today. But its coup de grâce was a variable wheelbase that allowed the car to be a half-decent length for driving around – vital for high-speed stability – but then retract within itself, almost as if it were standing on tiptoes, when you wanted to park.

On top of this, the doors opened upwards like a beetle's wings, meaning it could be extremely narrow for threading through tight spots, but still a reasonable size inside. Inspired stuff. And then they gave us the Twingo.

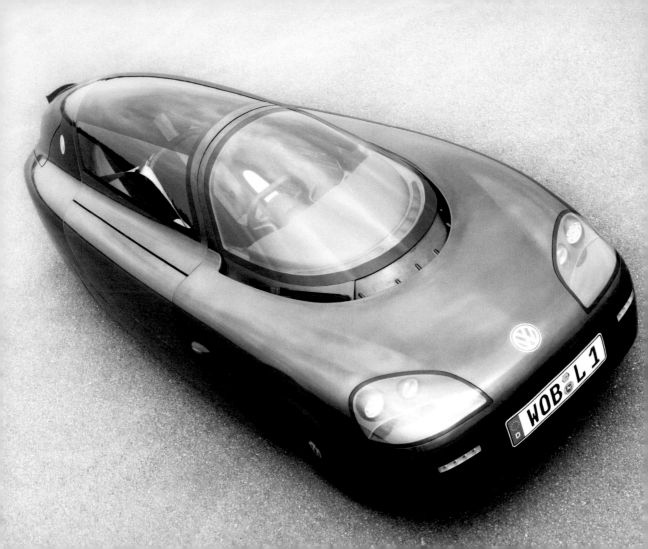

Year: 2002
It works brilliantly. Both as a car and a coffin.

VOLKSWAGEN L1

At the start of this millennium, diesel suddenly became rather fashionable. Not wasting every available shekel on filling up your car was always going to be a tidy sales pitch, but with the new-found spectre of global warming and the fact that the diesel engine was now marginally smoother than a vintage tractor, the renaissance was unstoppable.

More miles per gallon was the new black, and the vanguard of this vogue was none other than Volkswagen, who in the spring of 2002 unveiled the '1-litre'. Less had definitely become more: a one-cylinder 300cc engine produced a measly 8bhp; no matter, because the whole car weighed only 290kg. Meanwhile super-slippery aerodynamics, aided by driver and passenger having to sit behind one another, reduced drag to virtually nothing, too, with a truly remarkable outcome. The 1-litre was so named because it only used a litre of diesel for every 100km it drove – in old money, that's around 285mpg. Good news for everyone, except BP.

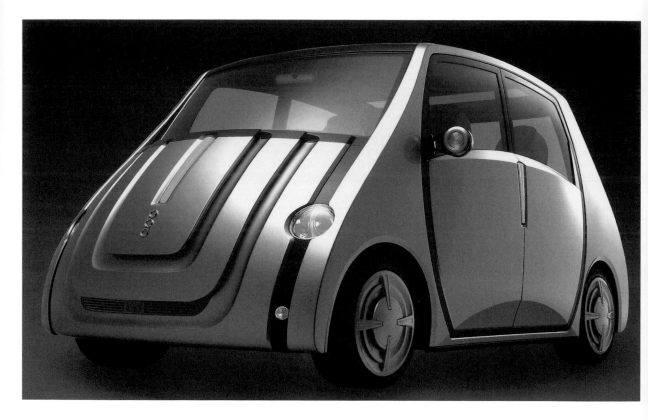

Year: 2002
A car with depressive tendencies? Does it top itself if you trade up?

TOYOTA POD

If there's anything that science fiction has taught us, from *2001: A Space Odyssey* to *The Terminator* and beyond, it's that giving machines artificial intelligence is a very, very bad idea. Before Toyota's POD turns round and kills the lot of us, however, it will learn about your habits and preferences, monitoring your pulse, level of perspiration and driving input through the wheel and pedals. This information is then processed by the POD, which decides how it feels in response, a sentiment it then reveals to the outside world by a series of illuminated strips on the bodywork.

Normal conditions evoke a nice orange glow, meaning the POD is working fine and quite happy to be with its owner. If, however, said owner is driving like a tit, the POD goes red – with empathy or shame, who knows. If it's left alone for too long or runs out of petrol, it goes blue to let us all know it's feeling sad. And just for good measure, it has an antenna that wags like a dog's tail when it's back to feeling tickety-boo.

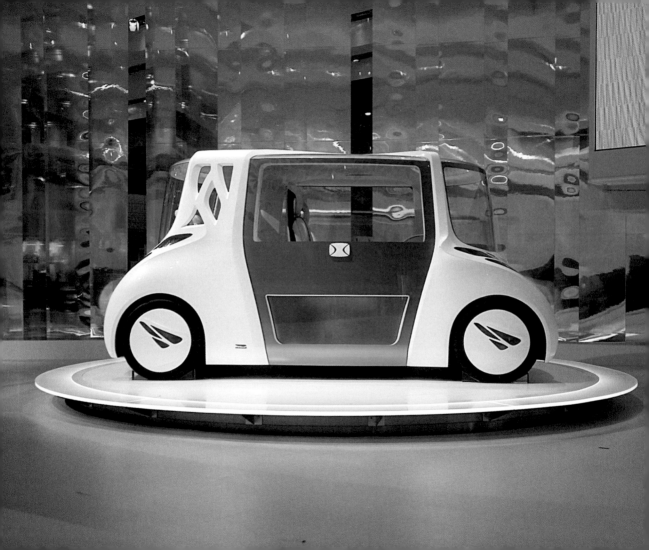

Year: 2007
There's a tree in the boot. What could possibly go wrong?

TOYOTA RiN

Manufacturers are always banging on about active and passive safety, five-star crash-test ratings and curtain airbags. It seems the best way to sell a car these days is to convince prospective buyers that it isn't going to kill them. So Toyota, in the way that the Japanese do, took this idea on a bit and came up with a car that doesn't just stop you dying, it actually makes you healthier first.

The RiN is a car determined to take the stress out of driving. Its whole design motif is based on the yakusugi tree — apparently to reflect harmony with nature — backed up by low-lying windows that will keep both driver and passengers in touch with the outside world at all times. Inside the seats are fiercely upright, but this will provide the best possible posture, which ultimately leads to greater mental and physical well-being. And the green glass brightens your surroundings while filtering out harmful UV and infrared rays. All clever stuff, but the deal breaker is the mood-training steering system. This is a device that monitors your temperament through steering input and displays the correct mood-altering colour to adjust it accordingly. Kept sufficiently Zen, road rage will be a thing of the past. And we'll all have the posture of a drill sergeant.

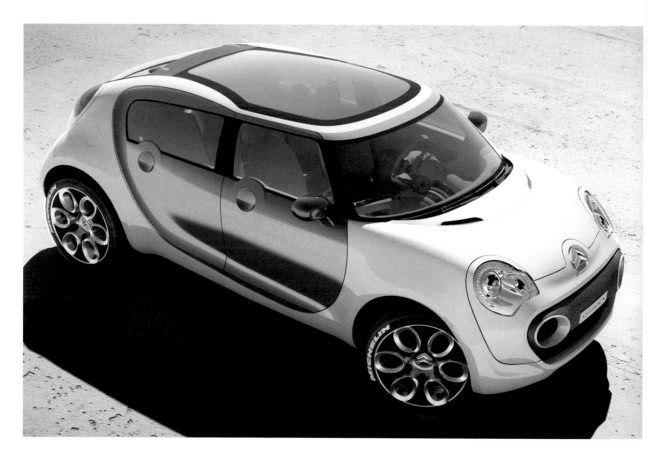

Year: 2007
Worryingly likely. Wind down your windows while you can.

CITROËN C-CACTUS

In turbulent financial times it's hard to do noble things. Who buys organic carrots when they're half the size and cost twice as much? So Citroën has devised a way of mopping the environment's troubled brow while saving you a penny into the bargain. The C-Cactus is made up of a minimum number of parts, so it's cheaper to make and therefore buy. The windows don't go down, the bonnet and boot are fixed, the glove box is replaced by a clip-on bag, and there's no dashboard, just a display on the steering wheel.

And many of these bits and bobs are constructed out of recycled and biodegradable material. There's felt lining and cork padding, and the only leather is offcuts that have been stitched together and used on the floor. Even the doors have gone unpainted to save any unnecessary expense. Couple all this to a hybrid diesel engine capable of around 80mpg and arguably you have the ultimate car for the twenty first century: recycled, recyclable and, theoretically, cheap as chips. Although not organic ones.

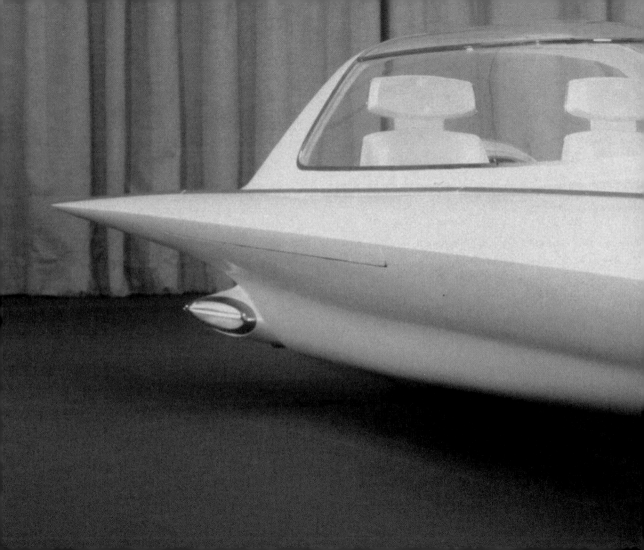

4 THAT SHRINKING FEELING

The benefit of the doubt has run its course, and a sneaking suspicion is creeping in that the people behind these cars are in very real need of firm psychiatric intervention.

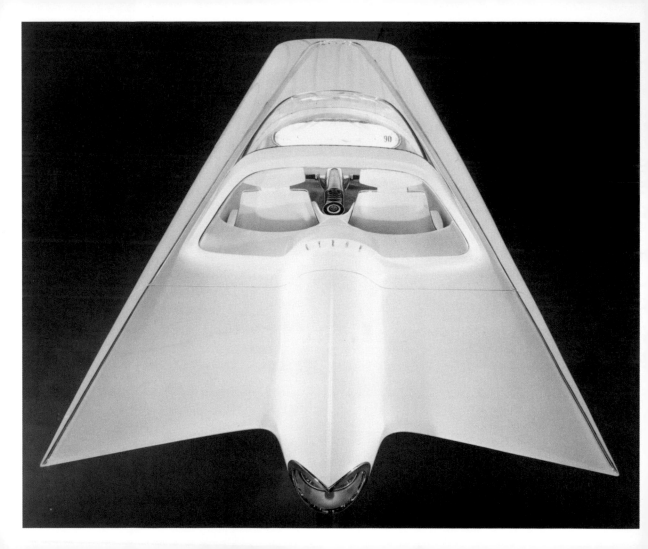

Year: 1961
Highly feasible this one. They could call it a 'motorbike'.

FORD GYRON

The 'if it ain't broke' adage could hardly be more apt than when it comes to penning new cars. Four wheels, for instance, are a good idea. Three, history has ably demonstrated, are not. Two? Now that's just a motorbike, right? Not if you worked for Ford in the '60s.

The Gyron was a sincere exploration of the possibility of having a two-wheeled car – laid out front and rear just like a bike – that was then stabilised with gyroscopes. And when they say stabilised they mean prevented from falling over every time you dared try to turn a corner. If you wanted to stop meanwhile, the Gyron would be forced to reveal two little legs from within to support itself, acting much like a motorbike kickstand. In fact, on closer inspection, this is just a really wide motorbike, isn't it? With a roof and stuff. Small wonder the one and only Gyron was tragically lost without trace in a fire. Ford's insurers won't have batted an eyelid.

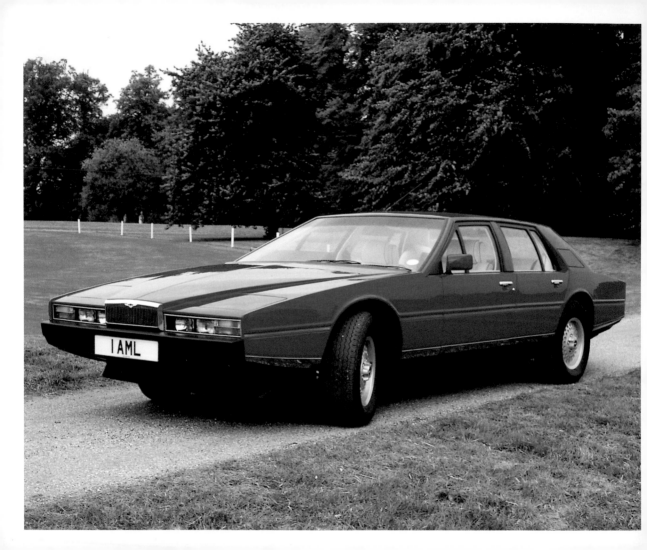

Year: 1976
They made it. In a manner of speaking. And still no one can quite believe it.

ASTON MARTIN LAGONDA

Back in the mid-1970s, much like the middle of any other decade you care to mention, Aston Martin was about to sink without trace. It'd been turning out cars for the quintessential British sporting gent for yonks, but such a chap was becoming an endangered species. What was needed, reasoned the men in (very expensive tailored) suits, was an ultra-high-tech limousine, shaped like a paper dart, that would sell for roughly ten times the national-average house price. Unbelievably, it turns out they were wrong.

The Aston Martin Lagonda remains one of the great white elephants of the British motoring industry. Its on-board computer gimmickry is said to have cost Aston four times the budget they had set aside to build the entire car. And almost none of it ever worked. To make matters worse, this vast, unimaginably expensive and futuristic executive saloon was powered by a truly archaic carburetted V8 and crummy three-speed gearbox that provided fuel economy poor enough to create an oil crisis all on its own.

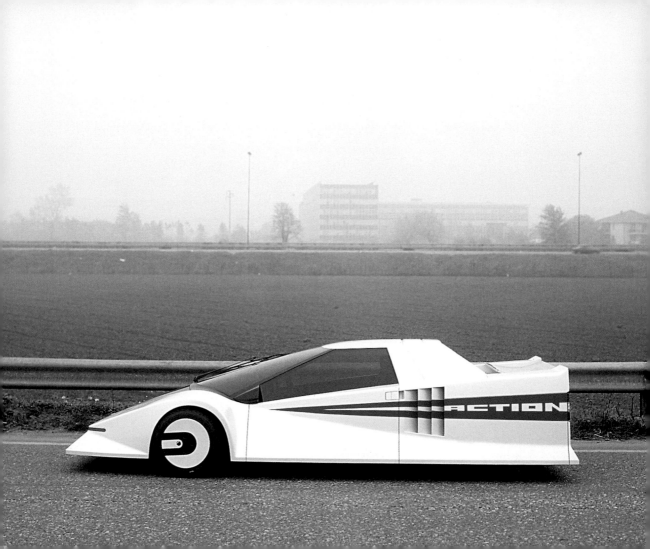

Year: 1978
If you're George Lucas, and you live in Dagenham, why not?

GHIA ACTION

Towards the end of the 1970s the wedge was still king, but the incoming influence of dodgy '80s design motifs, like geometric stickers and pointless vents, was already rearing its ugly head. Ford commissioned its styling buddy Ghia to come up with a sports prototype to sex up the company's slightly shaky European image; the result was this, the Action. It's hard to imagine a name more vague and dated, nor, as it turns out, more hopelessly ambitious.

What Ghia did was pinch the chassis from a Ford Escort and a contemporary V8 engine from a Formula 1 car, then hide it all under some ultra-wide plastic bodywork stolen from a *Star Wars* toy. Actually, the result looks utterly tremendous in a Grace Jones on Betamax sort of a way, but they'd put you on suicide watch if you volunteered to drive it.

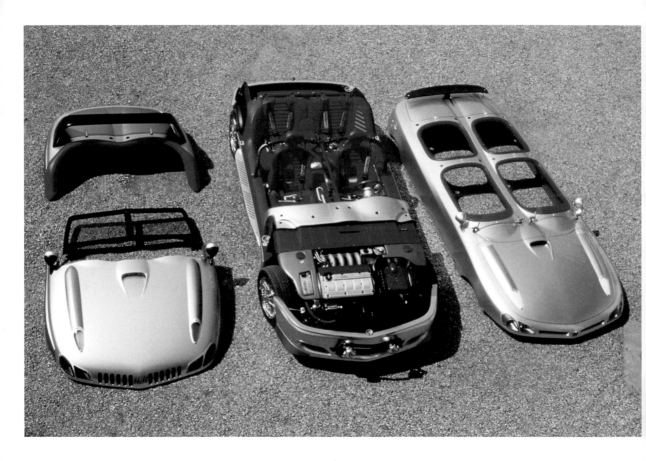

Year: 1996
DIY car production? It could happen. But most of us would die.

ITALDESIGN FORMULA HAMMER

Maybe Italdesign came in for some heavy flak. Maybe it simply couldn't be arsed any more. One way or another, an executive decision seems to have been taken in some smoky boardroom decreeing that the only way to please all the people all the time was to make the people bloody well build it themselves. Enter the Formula Hammer.

One can only imagine that the name is some sort of in-joke, when Italdesign downed tools in the expectation that we, the bemused public, would pick ours up and finish the job for them. What they would call modular, we would call Airfix. Want an open-air four-seater? Do it yourself. It's raining now, is it? Roof's in the box. Cold? Go get the doors. What? Now you want an individual cockpit for every passenger? Oh, hang on, there's one of those too. What were the odds on that? This is flat-pack industry to put the Swedes to shame.

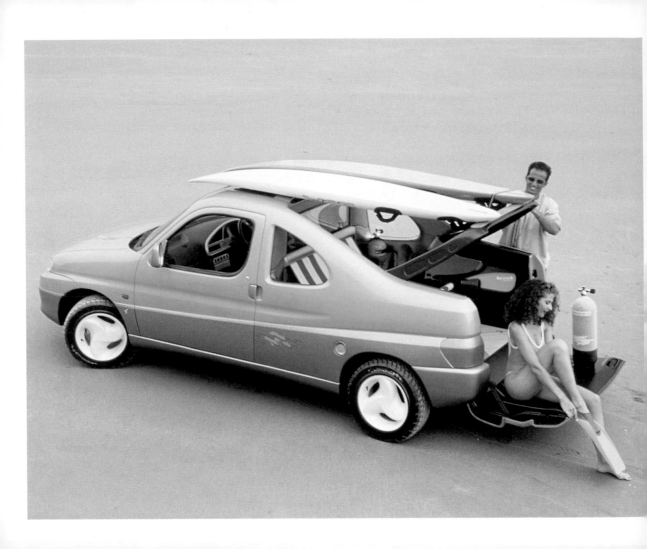

Year: 1999
Put nothing past Citroën. The more useless, the more likely.

CITROËN BERLINGO
COUPÉ DE PLAGE

It must be the stuff of nightmares for marketing men, when the bean counters decree that they're going to turn a panel van into a family car. How do you sell that as a sexy lifestyle statement? How do you distract enough people from the fact that their shiny new MPV is really just a commercial grunt wagon with a few more seats and windows? You take them to the beach, that's how.

The Citroen Berlingo is just such a van; as the Berlingo Coupé de Plage, all of a sudden it's a racy, extreme sports-equipped two-seater, groaning under the weight of surfboards, girls in bikinis and the unstoppable fertility of all who drive it. Suddenly a practical, family-oriented purchase has become the very manifestation of your liberated, sexually potent manhood. Time to ditch the wife and kids and get back out there. Look at all those bleached-blonde girls in thongs. They're flocking towards you, running their hands over the rakish lines of the Coupé de Plage, admiring its sporting three-spoke alloys, wondering at the sheer impractical abandon of it, of you … of a life with you – something like that anyway.

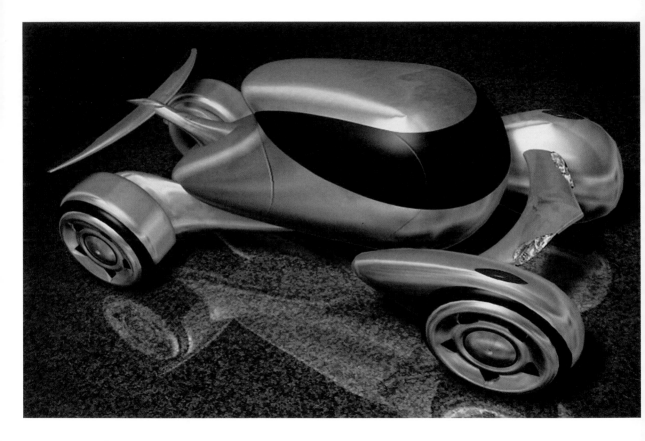

Year: 2001
In an alternative universe where cars serve absolutely no practical purpose.

PEUGEOT MOONSTER

Yet again at Peugeot the tricky balance between democratic ideology and buggering off for four-hour lunches has delivered a car so useless as to render its annual design competition null and void. The general public was first let loose to do Peugeot's job in 2000; on that inaugural outing, thousands of designs were submitted from eighty different countries. From a shortlist of no less than fifty, the judges still plumped for this, the Moonster.

The meaningless whimsy of a young Yugoslavian chap called Marko Lukovic, the Moonster has no engine, transmission or even suspension. Despite the name and appearance, it has no astronautical application either, instead being intended to serve as an urban vehicle of the comparatively near future. Its highly polished, pre-formed aluminium structure is said by Lukovic to have been inspired by dolphins, while the metre-high wheels are, in his mind, like an animal's legs. Don't let these people out for the day.

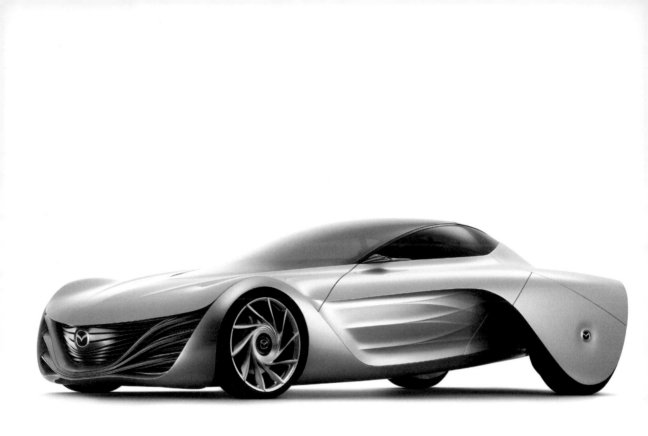

MAZDA TAIKI

Never one to be left behind in the hotly contested battle for who can overthink everything as much as possible, since 2006 Mazda has unveiled a series of cars styled to represent the movement of wind, something it calls *nagare* or 'flow', round the office. And the last of them, the Taiki, took the whole thing to a final extreme. *Taiki* means 'atmosphere' in Japanese, as in that thing overhead rather than what you get in a nightclub. It's all something to do with wrapping the Earth in Mazda's protective shroud of eco-goodness, what with the Taiki being released at the Tokyo Motor Show in 2007 under the slightly indigestible banner of 'Sustainable Zoom-Zoom'.

The Taiki's body is supposedly inspired by the wind rushing through a pair of *hagoromo*, which are, they say, 'the flowing robes that enable a celestial maiden to fly'. Come again? But apparently this is the real deal. Not only does the Taiki debut all sorts of clean, green rotary-engine technology, but it also underlines Mazda's design direction for future models. Sure it does.

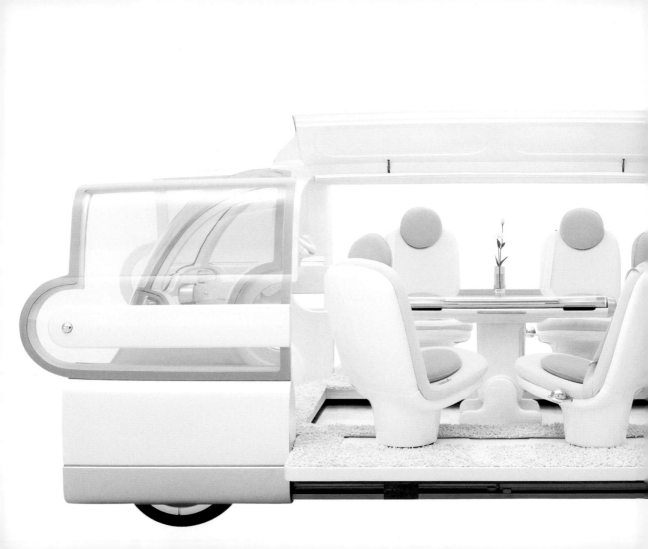

5 BREAKFAST IN BEDLAM

Between spending the whole time slumped over the easel and one too many trips to the coffee machine, is it possible for a designer to forget what a car is actually for? Er, yes ...

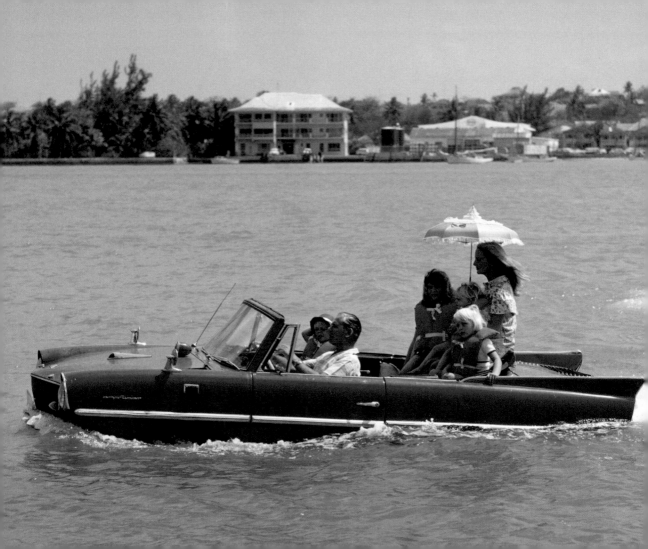

Year: 1961
In 1961 anything was possible. By 1968 you could cross swimming cars off the list.

AMPHICAR

The '60s was a decade of great ambition, liberation and bold innovation, supplemented by lorry loads of hallucinogenic drugs. Even in Germany, apparently, where history's only mass-production amphibious car appeared in 1961.

The Amphicar lasted for five years, and in that time around 4000 units were painstakingly knocked together, most of which, perhaps unremarkably, found their way to the United States. Probably not unaided, but you never know.

Despite being a comparative triumph in the wholly unnecessary world of watertight motors, the Amphicar failed for various reasons. It looked spectacularly stupid out of the water, and like it was sinking when in it. It was also hugely expensive – something of a deal breaker when one considers the simple merits of earlier design solutions like 'the bridge' and 'the ferry'. It was also a rubbish car and an absolutely lousy boat. Nevertheless, two Amphicars did cross the English Channel in 1968, apparently in a storm. For that we all must doff our caps. And counsel our children about the perils of recreational drugs.

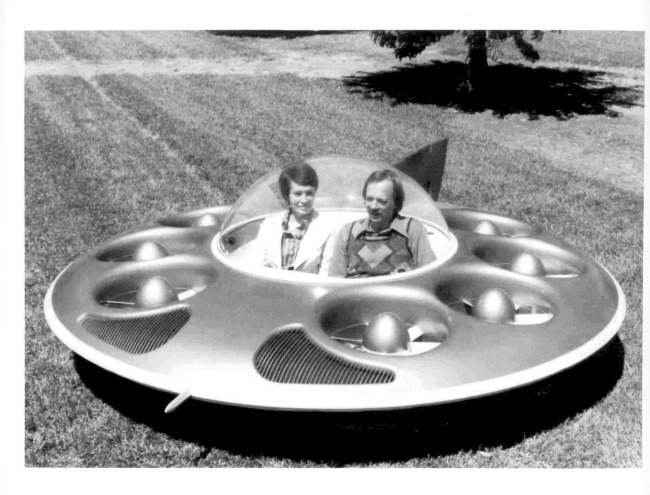

Year: 1974
Depends who you talk to. (Don't talk to anyone called Moller.)

MOLLER M200G

When tossing around ideas for a flying car, settling on the one favoured by genocidal aliens from the '50s was always going to involve an element of risk: Is this the Martian attack we've always secretly feared? No, it's Dr Moller coming for a pint of milk. So not the Mekon flying saucer it appears to be, but rather the very real, and on sale, brainchild of American Dr Paul Moller, the M200 is one of the first, and most infamous, flying cars to have made it into 'production'.

Using a series of rotary engines to power what look like desk fans, Moller's two-man saucer will hover precariously over almost any surface. Then it sort of wobbles backwards and forwards, and everybody shuts their eyes. One that can only go up 10 feet will set you back around $90,000, while aiming higher could call for more like $450,000. But Moller is deadly serious about it, touting the possibility of selling M200s to Joe Public for kicks, the military for killing people (hopefully not the pilots) and even to the emergency services as a means of rescuing people from skyscrapers. One by one.

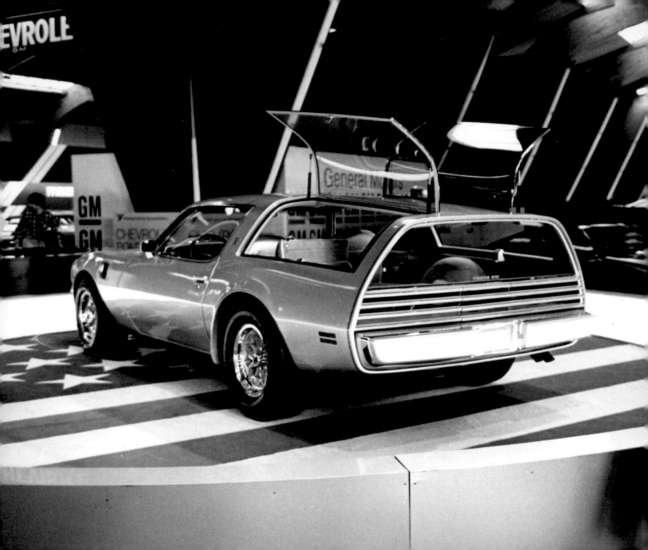

Year: 1978
It was this or birth control, but full marks to Pontiac for effort.

PONTIAC FIREBIRD TRANS AM KAMMBACK

Back in '70s America, the Trans Am was the stuff of blue-collar legend, an affordable muscle car designed for spearing across that vast continent at impossible speed – or going to the drive-thru McDonald's with your girlfriend before reclining the seats and getting her pregnant. When this happened, as it was wont to do, a problem arose that was costing Pontiac far too much of its virile market share. And so entered the Kammback, the solution every frustrated young father had been praying for. A blue-collar sporting legend mated with an enormous station wagon – 'Who's your Daddy meets Where's my Mom?' Surely an infallible business plan.

The principal drawback should have been fairly obvious, but it took actually building a Kammback for the penny to drop. Never before had such an irrefutable expression of masculinity been so comprehensively castrated. And seldom had something that looked so good morphed so readily into something so, well, shit. With glass gull-wing windows to provide some sort of access to the vast and otherwise impenetrable boot, Pontiac's V8 estate was a design cock-up of historic proportions.

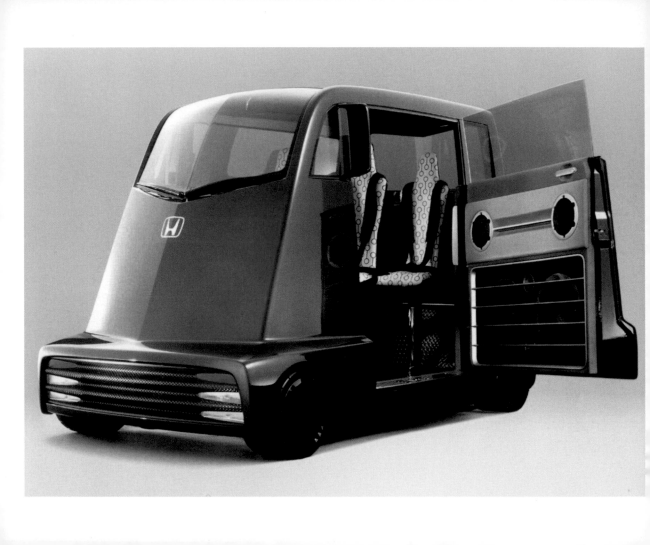

Year: 1999
Hello Constable? Us, drinking? Surely not.

HONDA FUYA-JO

Always tackling problems head-on that simply weren't there in the first place, Honda came up with an inspired idea for getting the traffic cops to sweat a bit harder. The Fuya-jo is a mobile-bar-cum-nightclub. Drinking and driving, all rolled into one neat, little urban package. Ingenious.

The name means 'Sleepless City', a reference to the fact that this car is designed solely to transport drug-crazed revellers from one nightspot to the next without enduring the mortifying comedown of having to cross a threshold marked 'Exit'. The dashboard is styled to reflect a DJ's mixing desk, with the steering wheel as the turntable, and the four seats are deliberately ultra-upright so that if feels more like you're still standing on the dance floor. And that floor is made of non-slip metal, so you can spill your drinks without fear of coming a cropper. Concerned parents need not worry though. Underneath all this lurks Honda's hybrid running gear, so the Fuya-jo guarantees environmental sensitivity in every booze-fuelled city rampage.

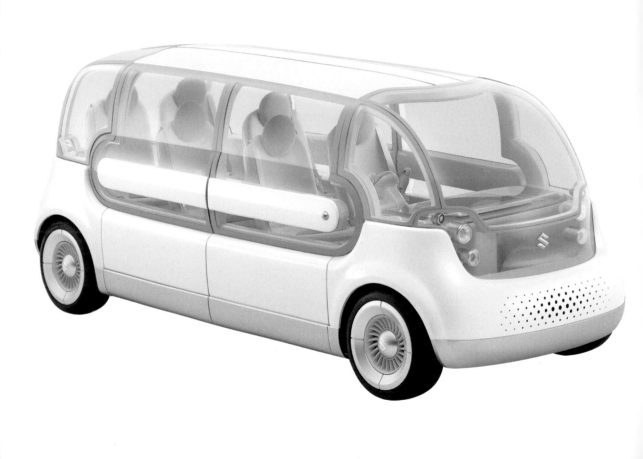

Year: 2003
Ah, a patio with wheels. You'd been after one of those for years, right?

SUZUKI MOBILE TERRACE

Although it's always commendable when a product does what it says on the proverbial tin, cars have a tendency to be distressingly literal. You'd assume, for instance, that the Suzuki Mobile Terrace wasn't actually that. After all, what in the name of all things ungodly would be the point? But here it is. A car that you drive somewhere and then just sit in, admiring the view or whatever it is you do on the terrace. Clean up last night's dog poo.

The truly worrying thing about the Mobile Terrace is just how much time, energy and money Suzuki has invested in circumventing the dark arts of 'Opening a Door' and 'Getting Out'. When the driver and any of the five passengers have selected a suitable beauty spot, they stop, and both the car's double side-doors automatically slide open, making room for the floor, which has been finished to look like gravel, to slide out. Then all the chairs can swivel around a central table that emerges from the floor, while the dash folds down to become another table. Because you can never have too many tables in a car, can you?

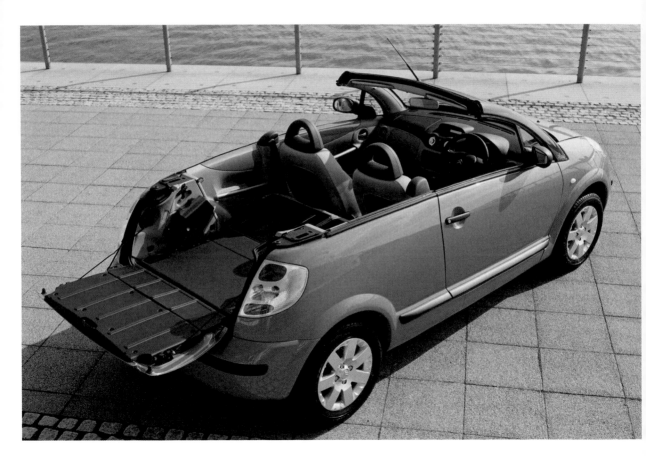

Year: 2003
No point in making this. No one would buy it. Would they Citroën?

CITROËN C3 PLURIEL

In the interests of fairness it's important to point out that although manufacturers do lavish an alarming amount of cash on designing and building completely ridiculous cars, most of them never actually see the inside of a showroom. If only Citroën could say the same about the Pluriel.

Here is a car with schizophrenia fitted at no extra cost. It is, on first inspection, just a dreadfully ugly hatchback. Then, after some fiddling and cursing, it's a 'Panoramic Saloon', according to Citroën, which is just a hatchback with a big sunroof to the rest of us. Then, after some broken fingernails, it's a convertible. Sort of. Add to the mix some confusion, stir in a dose of irritation and maybe even a trip to A&E, and it's become what Citroën want you to call a Spider. In truth you've simply removed the roof rails, and now have nowhere on board to stow them in the event that it rains. Then, and here's the one none of us could live without, you fold down the rear seats, and it's a pick up. But an illegal one on UK roads, because you can no longer read the rear number plate. Special.

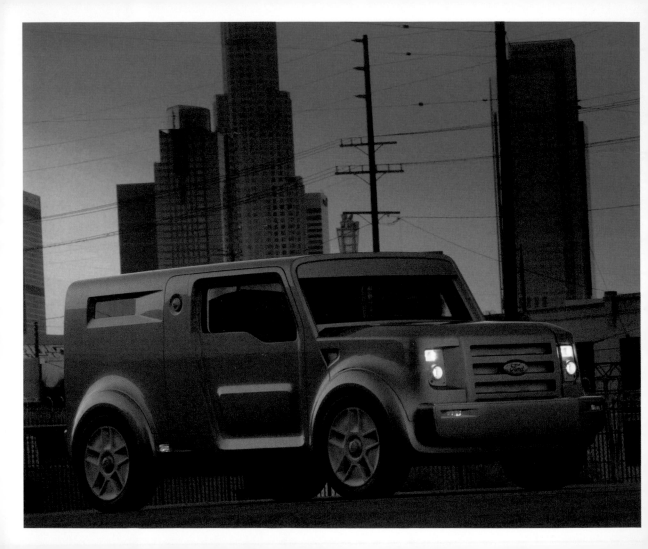

Year: 2005
More 'me time' for crooks, with a bank vault and getaway car in one.

FORD SYNus

Embracing twenty-first-century America's sentiment of distrust and paranoia, in 2005 Ford unveiled the SYNus, a car that borrows its aesthetic influences from a bank vault. No, seriously. First off, let's deal with the name. 'SYN' is an abbreviated 'synthesis', something to do with the link between its tough exterior and soft interior. Think liqueur chocolates. Or an armadillo, Ford says. And the 'us' bit is short for 'urban sanctuary', as in a place where you can hide when the War on Terror goes tits up on home turf again.

The SYNus is designed to maximise occupant safety, with its bullet-proof windows and bodywork, and features a lockdown mode that brings down steel shutters over all the glass and lights. When in this state of isolation, huddled in the back in abject terror while waiting for the world to end, passengers can swivel the rear seats round and watch films. That'll take their minds off it.

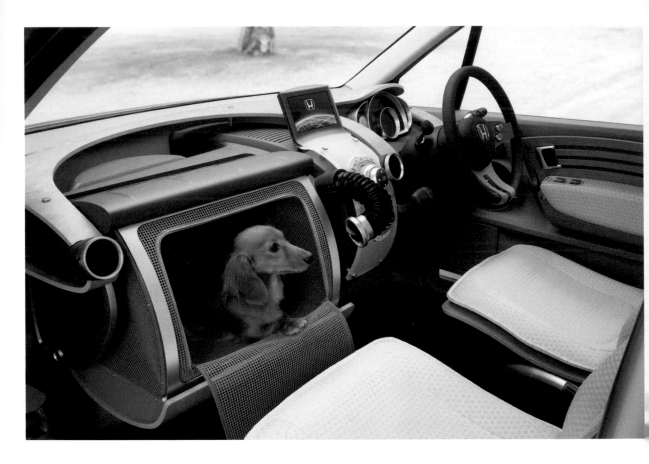

Year: 2005
It's a wipe-clean van. They already have these at football matches.

HONDA WOW

It's meant to be a yardstick of a civilised society, how we treat our animals.
It Girls have designer handbags for the sole purpose of ferrying the pooch
about, and the queen takes her corgis on the royal jet. Ever thoughtful Honda,
however, is bringing canine devotion to the masses.

 'WOW' stands for Wonderful Open-hearted Wagon, the sort of thing no
one bats an eyelid about in Japan. And the name is the least of our worries.
In essence the WOW is an MPV where the dog comes first and its owner a
distinct second. The glove box has been replaced by a dog crate, so a beady
eye can be kept on the driver at all times. A larger crate pops out of the floor in
the back, where rear passengers might have hoped to sit, and there are floor-
mounted dog seat belts in case of anything untoward. And, should the worst
happen, the WOW's warm wooden floor is covered by fully removable and
washable matting.

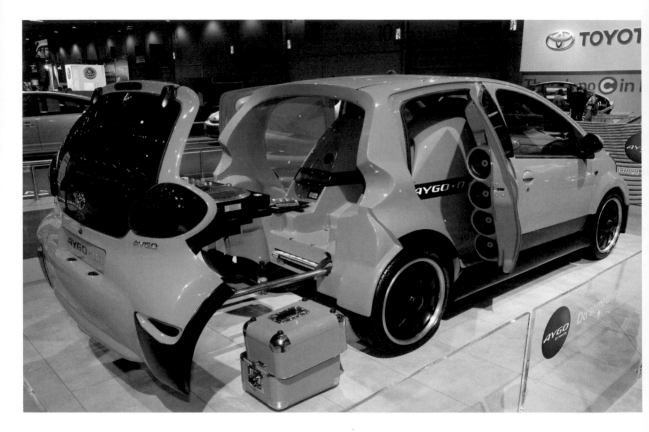

Year: 2006
There simply aren't enough ASBOs to go round.

TOYOTA AYGO DJ

Desperate to keep up with contempo culture, Toyota has created the stuff of sweaty adolescent dreams for a broad subsection of Britain's feral ASBO generation. By taking a cheap, ubiquitous hatchback – itself a must for spotty modders – and turning it into a bright orange, mobile PA system, Toyota has fulfilled every imaginable life ambition for great swathes of our country's pre-imprisonment progeny.

The Aygo DJ forgoes anything as middle-aged and square as back seats in favour of a telescopic DJ booth that slides out on steel struts to reveal twin record decks and a sound mixer. Inside there's storage close at hand for the vinyl and glow sticks, and the rear doors open to reveal a massive high-end speaker system, large enough to project a granny-baiting cacophony right across any suburban rain-soaked car park.

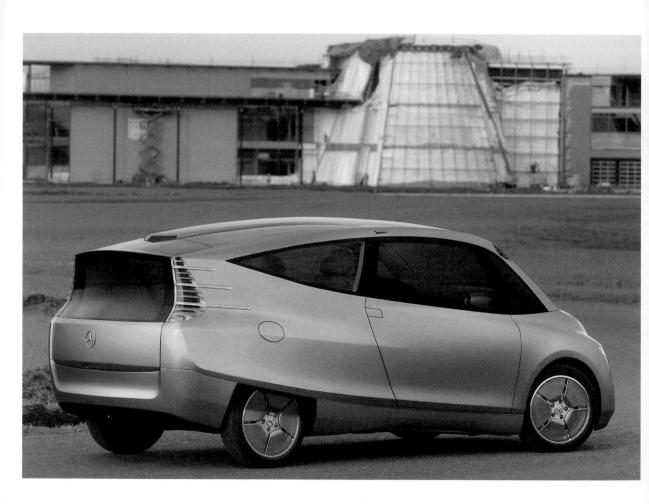

Year: 2005
Free portion of chips with every down payment.

MERCEDES-BENZ BIONIC

Inspiration can be dragged up from almost anywhere when it comes to cars. Even, in the case of Mercedes, from the seabed. The Bionic first appeared in 2005 to be greeted by a lot of stony silence interspersed with sniggering. After all, it looked like a fish on a roller skate. But Merc had the last laugh, because that's exactly what the Bionic was. Or near enough.

In the dictionary sense of the word, bionics is the study of mechanical stuff that behaves like organic stuff, and the organic stuff in question this time was the *Ostracion cubicus* or yellow boxfish. Logical enough when you think about it. A fish is very slippery, so a fish-shaped car should be really aerodynamic. The boxfish has evolved to move with a minimum of effort, be highly agile and have a rigid exoskeleton to withstand the pressure of depth. So it followed that the Bionic would be fuel efficient, manoeuvrable and structurally tough. All vital things for a car to be. Rather more vital, however, is not looking like a fish. On a roller skate.

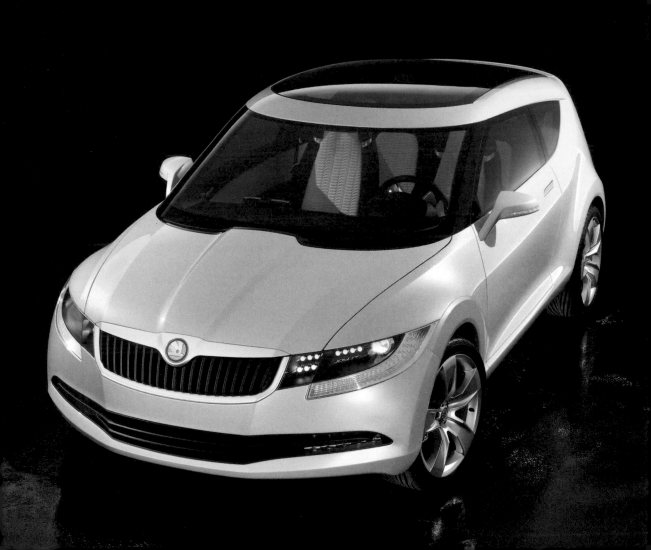

Year: 2007
Not half as hard to produce as it would be to sell.

SKODA JOYSTER

Bridging the cultural chasm between old and young has always been the Holy Grail of grey-haired marketing execs. Think Coke and Pepsi, Marlboro Man, Take That. If you can get the kids on side early, you've got 'em for life. And Skoda is right on the scent. There's a whole generation out there now that hasn't grown up assuming ownership of its cars was simply a punishment for being born on the wrong side of the Iron Curtain. They might actually like them. So Skoda's given its latest youth project the sort of name usually attached to battery-powered devices sold in Ann Summers. And why not? Sex sells. Cars are sexy. Kids have sex. In cars. It's a great business plan.

So what does the Joyster do? Surely it vibrates? Emits irresistible pheromones? Or at the very least has a love shack in the back? Not quite. According to Skoda's chief designer, Jens Manske, he wanted 'to create a young person's car' because young people are 'always interested in the latest technology and need practical solutions'. With that in mind he gave the Joyster a fold-out boot that reveals a pair of picnic seats. This is the Skoda Not Until We're Married. Maybe even the Skoda Christian Boot Camp.

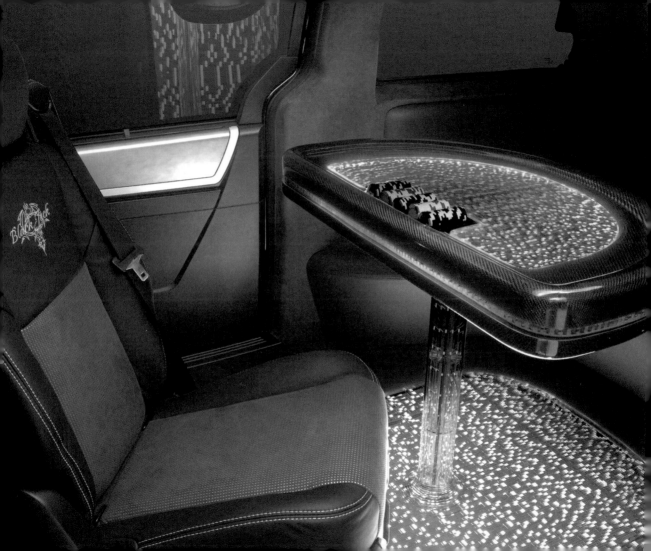

Year: 2007
Home from home for the amber gambler.

CHRYSLER TOWN & COUNTRY BLACKJACK

It's all a question of priorities. While the Japanese are spending decades and fortunes trying to make cars greener, healthier things to live with, and the Germans never cease in their efforts to produce the finest, fastest sports car, the Americans are busy turning MPVs into casinos.

The Chrysler Town & Country Blackjack has been cobbled together to emulate the Luxor Hotel in Las Vegas. Externally, it's your usual diva-spec, blacked out with nasty alloy 'rims' and pointless bits of chrome, but inside things go seriously off-message. The back row of seats has been dispensed with in favour of a curved, embroidered leather bench that faces a carbon-fibre blackjack table. The second row has gone too, so there can be a solitary seat for the dealer. The whole place is lit with a complex system of LED lights and reflective surfaces, all to emulate that seedy feel of a late-night lounge bar. There's a 37-inch LCD flat screen on board, too, and two 7-inch monitors overhead. These, in turn, are wired up to three hidden cameras, which constantly watch both the dealer and the players' hands. So, no cheating going on in there then.

6 DIVINE INSPIRATION

For all the jaw-dropping tosh that gets cobbled together in the name of progress, there is the odd success story. Style, vision, unchecked extravagance: not all daydreams turn into nightmares.

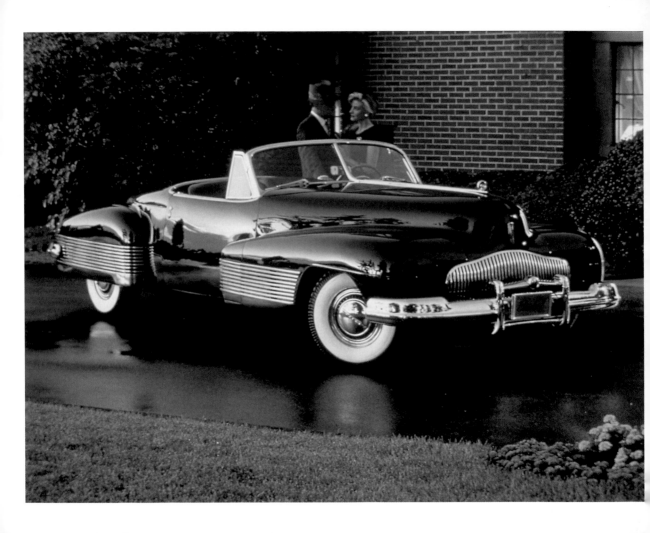

Year: 1938
They did it, just ten years before the world could cope.

BUICK Y-JOB

Beyond sporting a name that instantly elicits a titter, history will remember the Y-Job for being 'The First'. Look at the styling, and you think '50s Americana: drive-thru movies, flick knives, the Big Bopper and milkshakes. But, in reality, Buick created this thing way back in 1938, before Europe went to war again; when normal cars in America or anywhere else looked like biscuit tins with holes cut out for windows.

So the Y-Job enjoys the pretty extraordinary claim to fame of being the first-ever dream car; the original dream car for a generation bred on mechanical functionality. Designed by a guy called Harley J. Earl (and it sort of had to be, didn't it?), it was a showcase for what customers might be able to enjoy in the not-so-near future, with the type of curvaceous and powerful bodywork that would eventually come to define a whole era of American motoring. Other visionary features included automatic headlamp covers, a powered and fully stowed soft top and door handles that sat flush with the metalwork. It looked good then, it looked good thirty years later, and it looks good now.

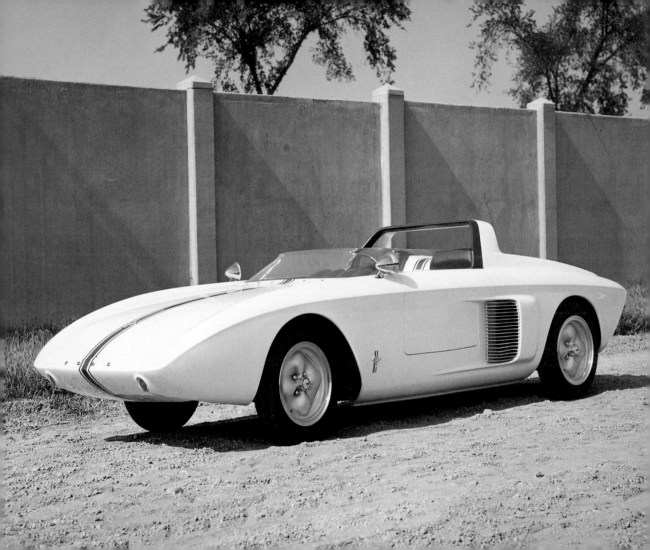

Year: 1962
A light, agile, pretty American car? Computer said 'Hell no.'

FORD MUSTANG 1

There was bound to be a hefty element of 'if only' in a chapter devoted
to those rare glimmers of brilliance in a swamp of dodgy automotive
experimentation. The Ford Mustang 1, for instance, is everything the actual
Ford Mustang wasn't, but in a good way. Conceived all the way back in 1962,
it was a small and highly capable lightweight aluminium two-seater with a
compact mid-mounted engine for ideal balance and handling. Not something
Americans tended to worry about – and still don't. The production Mustang
was a big, steel-bodied four-seater with a hulking V8 stuck to the front and
typically clumsy muscle-car composure. And it became one of America's
enduring motoring icons.

When the Mustang prototype made its public debut at the 1962 US Grand
Prix at Watkins Glen, Formula 1 driver Dan Gurney lapped it only slightly less
quickly than its F1 race-car contemporaries. It did the rounds of colleges for
a bit after that, used as a recruiting tool for Ford, and then someone shoved
it in the cellar and forgot about it.

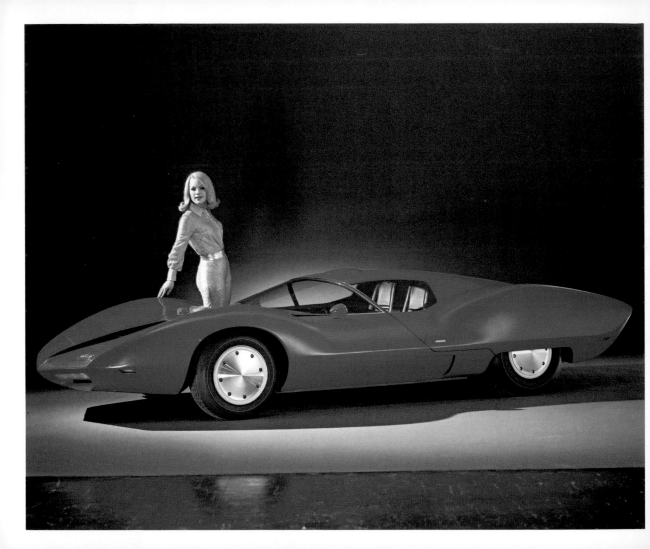

Year: 1967
You could hear the aneurysms in the GM boardroom.

CHEVROLET ASTRO 1

The frustration of designing sensible cars that someone might actually buy must be doubly bad when you work for the likes of GM. In the UK that's Vauxhall, of course, a company that doesn't do excitement, or performance, or sex appeal. GM, the world over, is all about middle management, cheap suits and lunch on your lap at the motorway services.

So imagine the US office back in the late 1960s. Some poor guy is sweating over the plans for another mid-priced, mid-sized beige saloon, and BANG! He bursts a blood vessel and out pops the Chevrolet Astro 1. The Chevy execs will have had a few questions to ask. Like, why is this practical family car less than 3 feet high? Where are the doors? Is anyone really going to be happy about having to climb in through the boot? And is that a periscope on the roof?

In truth, the Astro was an exercise in how aerodynamics and styling could work hand in hand. This meant it had to be that low to the ground, have a rear hatch rather than doors and a rearwards periscope instead of wing mirrors. Remarkably little of this ever made it on to the Vectra.

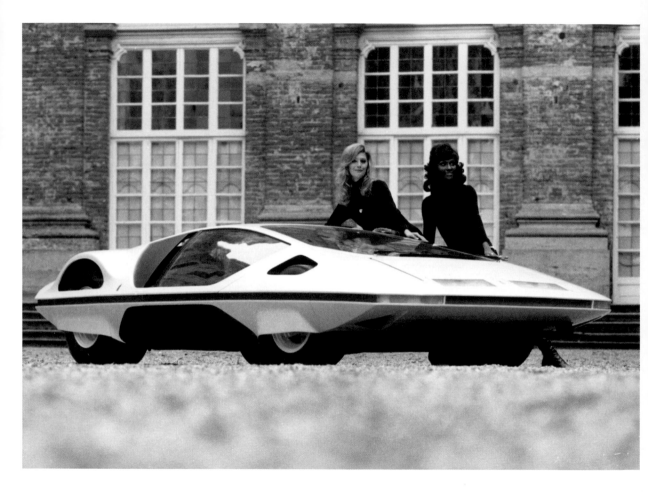

Year: 1970
Not being able to steer will tend to put the kibosh on things.

FERRARI 512 S MODULO

One of the many odd laws of sports-car racing is that you have to build and sell at least twenty-five units of any model to make it eligible to compete. Ferrari had a pretty lax interpretation of rules in those days and rarely bothered to sell any. In the case of the 512 S in 1970, they just started giving away half-built chassis to make up the numbers, and one ended up with Pininfarina. Who clearly had a field day.

Pininfarina are responsible for a staggering amount of Italy's automotive exotica, but they outdid even themselves with the 512 S Modulo. Here was a car that fulfilled every schoolboy's fantasy: sensual yet aggressive, plausible yet space age. Weighing just 900kg, despite having Ferrari's 5.0-litre V12 mounted amidships, theoretical performance would be immense now, never mind forty years ago. Theoretical it would have to remain, however, since the aerodynamic intent that led to all four wheels being partly enclosed also meant that you couldn't turn them. So, not that plausible after all.

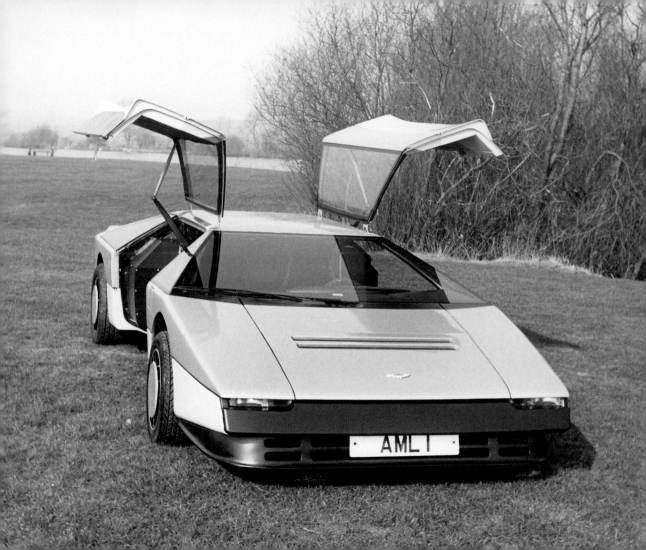

Year: 1980
It would've been a big hit. With the bailiffs.

ASTON MARTIN BULLDOG

When appreciating the significance of the Aston Martin Bulldog, there are a few things you have to remember. First up, a handful of years before it appeared the company was about to disappear without trace. Secondly, the reason for this is that Aston was only making one proper model at the time, which was about as sophisticated as a sailor on shore leave. And, thirdly, it had never made a mid-engined car before in its entire history but was about to knock one together with gull-wing doors and well over 200mph on the speedo.

The Bulldog was designed by the the man who designed the doomed Lagonda saloon, presumably in a desperate bid to save his own bacon, and it worked. Here was the ultimate '80s wedge, all aggressive angles and louvres. A twin-turbocharged 5.3-litre V8 was tuned to around 700bhp, kept in check by ingenious new ideas like split-rim wheels fitted with blades to channel air on to the brakes. The Bulldog nearly went into limited production, but the idea was deemed too financially risky; the one and only prototype was flogged off to a wealthy Arab, who ruined it with a nasty cream retrim and gold plate on the gearstick.

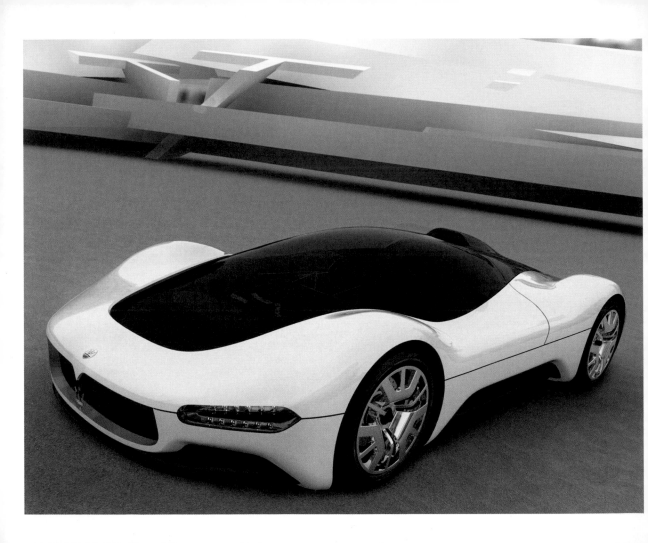

Year: 2005
A 700bhp vegetable steamer. Life was so ordinary without it.

MASERATI BIRDCAGE

The start of the twenty-first century has seen manufacturers get all worthy and serious about cars. Even stupid ones they have no intention of making are all about economy and the environment. This is a good thing, of course, but we still need the odd slice of bat-shit extravagance to keep our peckers up. So, thank you, Maserati, for the Birdcage.

Borrowing its name from one of the most celebrated '60s racing cars, the Birdcage was designed by Pininfarina for its seventy-fifth-anniversary celebration. It was that or cocktail sausages and pineapple chunks. The entire futuristic body is made of carbon fibre and powered by the same 6.0-litre V12 engine as the Ferrari Enzo, but in this case with a 700bhp race tune. The nose-to-tail blue-tinted bubble canopy lifts up and forwards for entry and exit, dispensing with such anachronisms as doors; inside a head-up display, the likes of which you normally get on fighter jets, projects your vital info on to a screen behind the wheel. The Birdcage has terrible visibility, there are no wing mirrors, and the absence of air con means it reacts like a greenhouse and slow-cooks its driver. But who wouldn't want to be cooked in that?

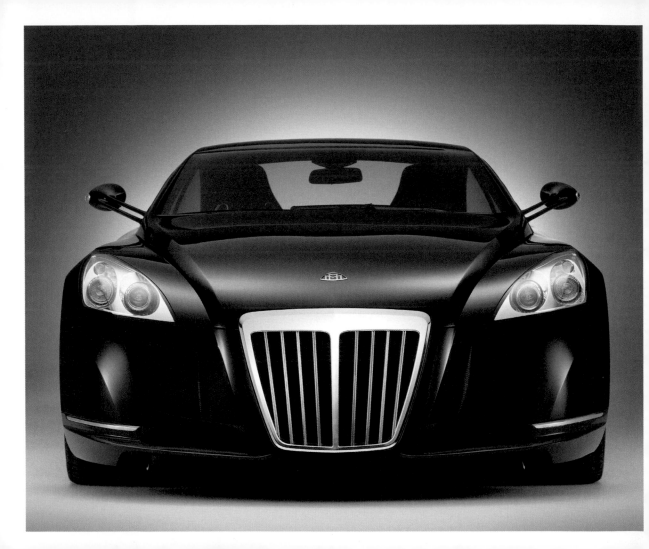

Year: 2006
Not unless there's a Nazi dictator or two on the order books.

MAYBACH EXELERO

If you were trying to explain exactly what is wrong with money to an extra-terrestrial being, the Mercedes Maybach saloon would be the ideal way of doing it. Vast, ugly, unnecessary, impossibly expensive and bought by people like Simon Cowell. And this alien would go away with a very clear picture, unless, that is, he'd seen the Exelero. This is a one-off coupé version of the Maybach, suitable only for megalomaniacs hell-bent on world domination or, at a stretch, Cruella de Vil.

The Exelero is almost 6 metres long, over 2 metres wide, but only a little over 1 metre high, giving it the sort of menace normally reserved for Mike Tyson's dates. It takes the 550bhp 5.7-litre V12 from the Maybach, bores it out and tunes it to 700bhp. This means that, despite sharing dimensions with a super tanker, it'll hit 60mph in 4.4 seconds and keep on going to over 218mph. Although effectively priceless, a valuation of around 5 million euros has been bandied about for this one-of-a-kind car. Steep that may be, but the Exelero is exactly what's right about money.

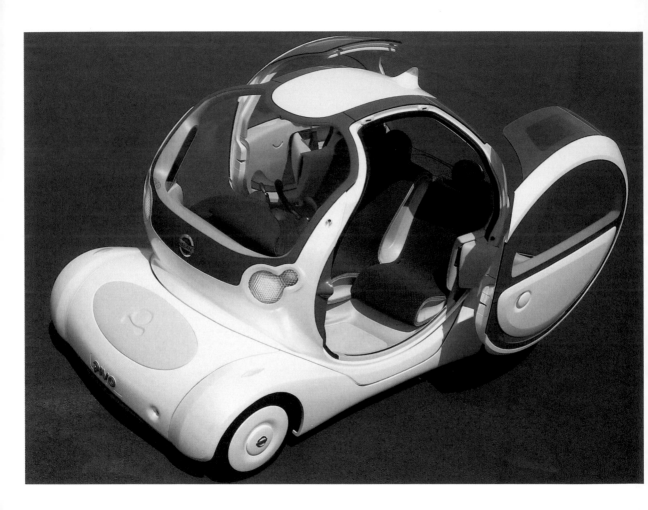

Year: 2006
There's a head on the dashboard. This isn't going to end well.

NISSAN PIVO 2

Take your driving test in this, and it's in the bag. The Pivo 2 is Nissan's answer
to the age-old dilemma of spatial awareness. Or a lack of it. The three-seater
cabin is a glass bubble that can rotate through 360 degrees on its chassis,
while the wheels positioned at all four corners can do the same. So what you
have is a car that can both look and drive in any direction. Pull up next to a
parking space and just crab your way in. Job done. Then the front slides open,
and out you get, always facing the kerb.

To make life even easier, if a little scary, Nissan has installed what it calls
a Robotic Agent in the Pivo 2, which takes the alarming form of an animated
head on the dashboard. It has a face-recognition system to familiarise itself
with different drivers and can hold conversations with you, in Japanese or
English naturally. So advanced and complicated is the Pivo 2 that one of the
agent's principal tasks is to explain how the hell to operate everything on
board, but it'll also tell you exactly where that parking space is and how
nice your hair looks. That last bit's a lie.

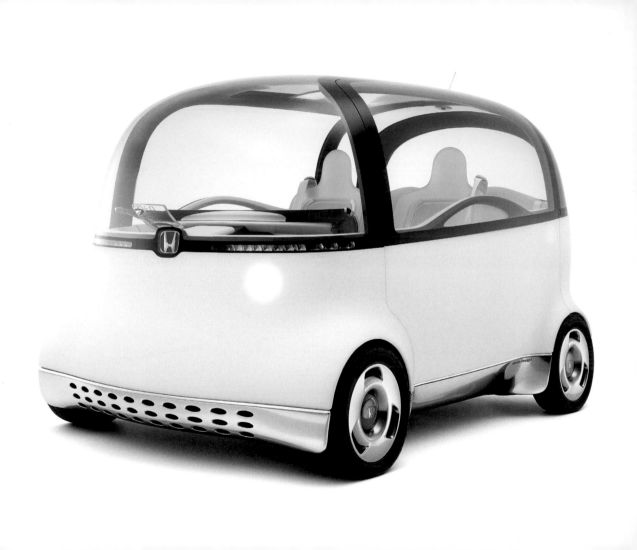

Year: 2007
It's a car made out of egg white. What could possibly go wrong?

HONDA PUYO

You'd think the capacity for reinterpreting the car would be finite. After all, wheels, doors, windows, engines – they have to be there. But in 2007 Honda unveiled the PUYO, and everything we know about cars came unstuck.

The name PUYO is a Japanese onomatopoeia that, in Honda's own words, 'expresses the sensation of touching the vehicle's soft body'. Presumably this is therefore a word that crops up regularly in considerably less salubrious walks of Japanese life, but right here its application is not only clean as a whistle but also literal. The PUYO is actually soft.

The whole purpose of this car is to be as non-confrontational as possible. It deliberately looks like it needs a big hug, and if you were to oblige you'd find it's made of a squidgy, gel-like material. This stuff is luminescent for increased safety at night-time and has obvious benefits for anyone on the receiving end of an impact. Other factors designed to melt the hardest resolve are a stretchy dashboard made of cloth and the ability to turn through 360 degrees on the spot, thus minimising aggro when you realise you've forgotten something. Like your manhood.

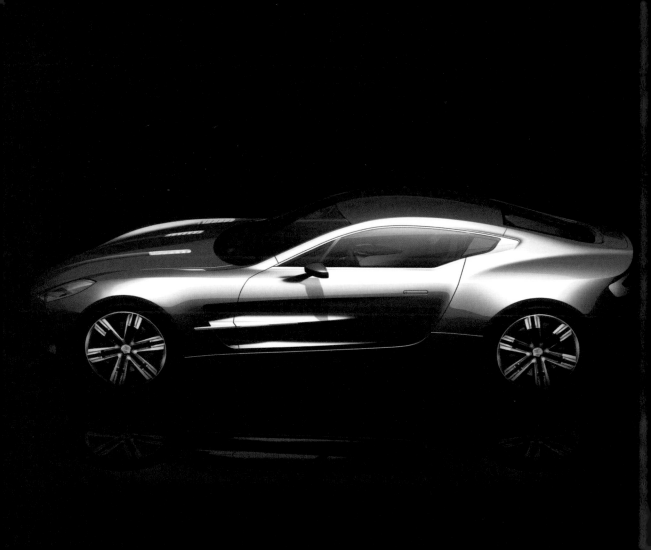

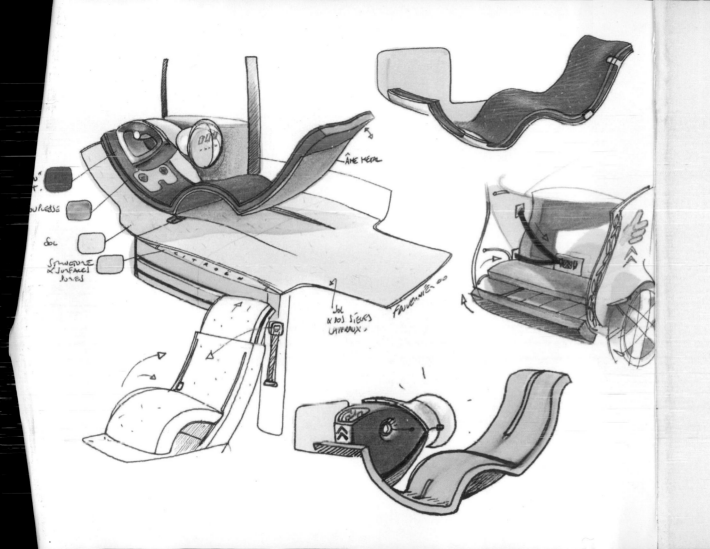

Year: 2008
A million-quid Aston Martin? That's proper business acumen.

ASTON MARTIN ONE-77

As this book is sent to press, the entire world is nosediving into the worst economic crisis for a century. High-street banks are crumbling on to the pavement, vast industries are simply shutting up shop and entire workforces are being sent home for an early bath. At this precise moment Aston Martin, a company that struggles to stay afloat in the boom times, decides to unveil a car that will cost one MILLION of your British pounds.

The One-77 is so named because they are going to make just 77 of them. Which seems modest, but when you're a small, independent British sports-car company that is now officially making a loss in the midst of the global economic apocalypse, selling 77 wheel nuts is a challenge. The One-77 has a bespoke carbon tub and outrageously complicated hand-built aluminium bodywork. Underneath that bulging bonnet is a gigantic 7.3-litre V12 that will deliver at least 700bhp via a race-style sequential transmission. Daft? Definitely. But in a good way. And, ultimately, it's only as daft as the people prepared to buy it. Just so long as they turn up …

10 9 8 7 6 5 4 3 2 1

First published in 2009 by BBC Books,
an imprint of Ebury Publishing
A Random House Group Company.

The Random House Group Limited
Reg. No. 954009.

Addresses for companies within the
Random House Group can be found
at www.randomhouse.co.uk

A CIP catalogue record for this book
is available from the British Library

ISBN 978 1 846 07807 1

The Random House Group Limited
supports The Forest Stewardship
Council (FSC), the leading international
forest certification organisation.
All our titles that are printed on
Greenpeace approved FSC certified
paper carry the FSC logo. Our paper
procurement policy can be found at
www.rbooks.co.uk/environment

Commissioning editor: Lorna Russell
Project editor: Christopher Tinker
Copy-editor: Helen Armitage
Design: Smith & Gilmour, London
Picture researcher: Giles Chapman
Production controller: Antony Heller

Colour origination by Altaimage
Ltd, London
Printed and bound in China
by Toppan Printing Co., (SZ) Ltd

Picture Credits

*BBC Books would like to thank the
following for providing photographs.
While every effort has been made
to trace copyright holders, we would
like to apologise should there be
any errors or omissions.*

Page 9 Helicron No.1 courtesy of Mick
Walsh; p.82 Amphicar courtesy of
Collections/Getty Images; p.86 Pontiac
Firebird Trans Am Kammback supplied
by Magic Car Pix (www.magiccarpix.
com), courtesy of Richard Dredge.
All other pictures sourced from the
Giles Chapman Library and from the
manufacturers; particular thanks to
Jackie Allard and Chrysler UK (p.105),
Bruce Calkins and Moller International
(p.84), Rachelle Chamberlain and
Suzuki GB plc (pp.80–1 and 90), and
Kate Thompson of Volkswagen Group
UK (p.56) for their help in tracking
down images.

Year: 2008
A million-quid Aston Martin? That's proper business acumen.

ASTON MARTIN ONE-77

As this book is sent to press, the entire world is nosediving into the worst economic crisis for a century. High-street banks are crumbling on to the pavement, vast industries are simply shutting up shop and entire workforces are being sent home for an early bath. At this precise moment Aston Martin, a company that struggles to stay afloat in the boom times, decides to unveil a car that will cost one MILLION of your British pounds.

The One-77 is so named because they are going to make just 77 of them. Which seems modest, but when you're a small, independent British sports-car company that is now officially making a loss in the midst of the global economic apocalypse, selling 77 wheel nuts is a challenge. The One-77 has a bespoke carbon tub and outrageously complicated hand-built aluminium bodywork. Underneath that bulging bonnet is a gigantic 7.3-litre V12 that will deliver at least 700bhp via a race-style sequential transmission. Daft? Definitely. But in a good way. And, ultimately, it's only as daft as the people prepared to buy it. Just so long as they turn up …

10 9 8 7 6 5 4 3 2 1

First published in 2009 by BBC Books,
an imprint of Ebury Publishing
A Random House Group Company.

The Random House Group Limited
Reg. No. 954009.

Addresses for companies within the
Random House Group can be found
at www.randomhouse.co.uk

A CIP catalogue record for this book
is available from the British Library

ISBN 978 1 846 07807 1

The Random House Group Limited
supports The Forest Stewardship
Council (FSC), the leading international
forest certification organisation.
All our titles that are printed on
Greenpeace approved FSC certified
paper carry the FSC logo. Our paper
procurement policy can be found at
www.rbooks.co.uk/environment

Commissioning editor: Lorna Russell
Project editor: Christopher Tinker
Copy-editor: Helen Armitage
Design: Smith & Gilmour, London
Picture researcher: Giles Chapman
Production controller: Antony Heller

Colour origination by Altaimage
Ltd, London
Printed and bound in China
by Toppan Printing Co., (SZ) Ltd

Picture Credits

*BBC Books would like to thank the
following for providing photographs.
While every effort has been made
to trace copyright holders, we would
like to apologise should there be
any errors or omissions.*

Page 9 Helicron No.1 courtesy of Mick
Walsh; p.82 Amphicar courtesy of
Collections/Getty Images; p.86 Pontiac
Firebird Trans Am Kammback supplied
by Magic Car Pix (www.magiccarpix.
com), courtesy of Richard Dredge.
All other pictures sourced from the
Giles Chapman Library and from the
manufacturers; particular thanks to
Jackie Allard and Chrysler UK (p.105),
Bruce Calkins and Moller International
(p.84), Rachelle Chamberlain and
Suzuki GB plc (pp.80–1 and 90), and
Kate Thompson of Volkswagen Group
UK (p.56) for their help in tracking
down images.

"PEAU" SYNT.

SOUPLESSE

SOL

STRUCTURE & SURFACES DURES

ÂME METAL

SOL & DOS SIÈGES LATERAUX.

FAUVENNE 00